IMAGES
of America

CLALLAM COUNTY

Clallam County, Washington

Pictured is a map of Clallam County, Washington.

Pacific Ocean

Tatoosh Island
Cape Flattery

Makah Reservation

Ozette Reservation

Lake Ozette

Quileute Reservation

Dickey River

Hoko River

Forks

Highway 113

Highway 101

Sol Duc River

Highway 112

Strait of Juan de Fuca

Lake Crescent

Lyre River

Lake Sutherland

Elwha River

Elwha Klallam Reservation

Port Angeles

Ediz Hook

Hurricane Ridge

Deer Park Road

Highway 101

Sequim

Dungeness Spit

Dungeness River

Diamond Point

Sequim Bay

Jamestown S'Klallam Reservation

N

IMAGES
of America

CLALLAM COUNTY

Clallam County Historical Society

ARCADIA

Published by Arcadia Publishing,
an imprint of Tempus Publishing, Inc.
3047 N. Lincoln Ave., Suite 410
Chicago, IL 60657

Printed in Great Britain.

Library of Congress Catalog Card Number: 2003103754

For all general information contact Arcadia Publishing at:
Telephone 843-853-2070
Fax 843-853-0044
E-Mail sales@arcadiapublishing.com

For customer service and orders:
Toll-Free 1-888-313-2665

Visit us on the internet at http://www.arcadiapublishing.com

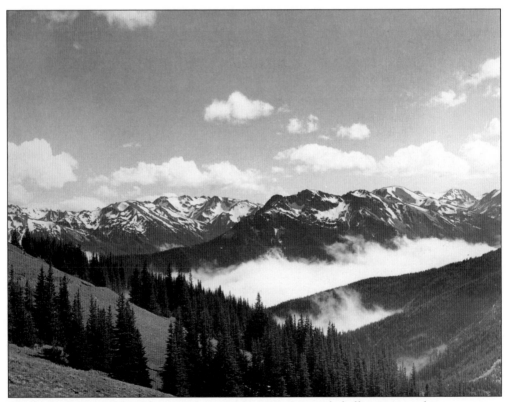

The Bailey Range of the Olympic Mountains remains snow-clad all year around.

CONTENTS

ACKNOWLEDGMENTS

This volume is the product of the Clallam County Historical Society in Port Angeles, Washington. Without the support of members of the Board of Directors who authorized it and the help of certain individual directors, the work could not have been accomplished.

We thank Director Frank Ducceschi and past President Ted Ripley for their consultation, advice, and direction when the project was first proposed.

We thank the many members of the Society—living and dead—who have donated their photographs to the archives of the Historical Society over the past 50 years to help preserve the history and culture of Clallam County. We have drawn heavily upon their photographs, many of which are appearing in print for the first time. Selection of the photographs has been made chiefly by Dona Cloud, archivist and photo editor. She was assisted by Alice Donnelly, Sandy Louch, Maxine Miller, and Kathy Monds, Administrator of CCHS.

We appreciate the willingness of individual and corporate contributors—Bob Clark, Gladys Snodgrass Kendall, the Sequim Museum and Arts Center, and the Washington State Historical Society—to grant permission to use photographs from their collections. We applaud Bert Kellogg, whose copies of historic photographs are included in the CCHS Collection as well as in other repositories. Without his persistence in finding and copying old photographs over a period of several decades, many images would have been lost to history.

We thank Director Ann Brewer who accepted responsibility for scanning the photographs, for the time and hours of service she has donated to the project—given the Society policy of not allowing photographs to be taken or sent away from Port Angeles.

We thank June Robinson, local historian and current president of CCHS, for her willingness to research and provide text and captions for this volume.

The Clallam County Historical Society

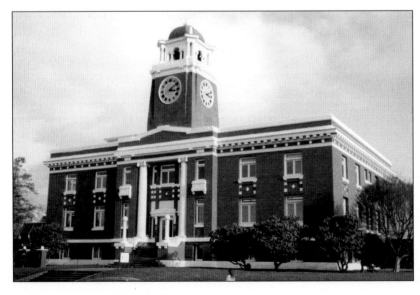

The handsome Georgian-style courthouse has been restored to its former appearance.

INTRODUCTION

A Brief History of Clallam County

Clallam County, Washington, the northern boundary of the Olympic Peninsula, extends approximately 90 miles along the shore of the Strait of Juan de Fuca from Diamond Point on the east, to Cape Flattery on the west, and 36 miles south along the "shipwreck coast" of the Pacific Ocean, to just below the mouth of the Quillayute River. The southern border is an arbitrary line drawn east to west across the rugged peaks of the Olympic Mountains. It covers 1,753 square miles. The population count was 64,525 inhabitants in 2000. Most of the land is rugged and forested. It is isolated and beautiful—one of the last frontiers in the contiguous 48 states.

One could say that the story of Clallam County began in 1596 when a Greek seaman named Apostolos Valerianos met Michael Lok, an English writer, and told him a fantastic yarn of sailing on a Spanish ship up the west coast of North America. He claimed that he had worked as a pilot under the assumed name of Juan de Fuca. The ship had sailed to somewhere between 47 and 48 degrees north along the coast of North America to a "broad inlet of sea" which they had entered and sailed east for more than 20 days until the captain was afraid they were getting close to the English colonies on the Atlantic coast and ordered the ship turned around and returned to the Pacific Ocean.

That story started a search for Juan de Fuca's strait—a Northwest Passage to the Atlantic Ocean which was to last for more than 300 years. In 1787 Captain Charles William Barkley actually found such an opening at about 48 degrees north and mapped it as the Strait of Juan de Fuca. Although Barkley did not venture into the opening he gave his maps to another British fur-trader, Captain John Meares, who sailed into the Strait, visited with a Makah chief, and named the island near the entrance Tatoosh Island. Meares had earlier charted a snow-covered mountain visible from the Pacific Ocean as Mt. Olympus, declaring it was fit to be a home for the gods. That name was later applied to the entire mountain complex.

A few years earlier, when Captain James Cook had sailed up the coast in 1778 searching for the Northwest Passage, he saw what he thought was a small opening at about 48 degrees north and "flattered himself" that he had found a harbor, but decided he was wrong and named the land south of the supposed opening Cape Flattery.

Spanish and English fur traders and explorers soon followed, charting and naming landmarks as they sailed through the strait. Captain Francisco Eliza mapped and named a deep harbor Puerto de Nuestra Senora de los Angelos—Port of Our Lady of the Angels—in 1790. A later mariner shortened it to Port Angeles. In 1792 British Captain George Vancouver sailed along the coast of what would be Clallam County and charted English names. He gave the name New Dungeness to a low piece of land 12 miles east of Port Angeles that reminded him of Dungeness in England.

These explorers were seeing a wild, tree-covered land, backed up against perpetually snow-covered mountains, fringed by a rugged, rock-bound salt water coast. Along the inland waters of the Strait of Juan de Fuca, sailing ships might find safety from imminent danger, but who knew what dangers lurked behind the forests that covered the land?

The Native Americans

Before the explorers, there were the First People. Three tribes shared the land that was to become Clallam County. The Klallams along most of the north coast, the Makah at the Cape,

and the Quileutes to the south along the Pacific Ocean. (See map on page 17.) They had traditional hunting grounds in the hills and mountains as well as their usual and accustomed fishing grounds along the coastal waters. These people have enriched the cultural history of Clallam County with their art, storytelling, and knowledge of nature.

The first settlers found the Klallam Indians living in 10 small camps or villages from the Hoko River to Discovery Bay. They were members of the Salish people from land east of Puget Sound. The name Klallam means "strong" or "mighty people." When the Treaty of Point No Point was signed in 1855, the Klallam people were expected to leave the peninsula and settle on a reservation at Skokomish on Hood Canal. They refused to move. They had ceded their land to the US government with assurances that they could continue hunting, fishing, and gathering in their traditional lands. In return the government promised education, food, job training, and supplies. Much later the government recognized two different peninsula groups as the Elwha Klallams and the Jamestown S'Klallams.

The Jamestown S'Klallams had no formal recognition as a tribe for years. Their fishing and hunting rights were not acknowledged. In the 1870s members of the tribe had pooled their money and purchased land at Jamestown, but Jamestown was not a reservation. In 1964 they began to seek formal recognition, finally receiving it on February 10, 1981. Today they own almost 300 acres of land. The Jamestown S'Klallams are engaged in a variety of economic and community enterprises and are working to revive traditional crafts and tribal history.

The Klallams in villages west of Ennis Creek also wanted to stay in their own villages when the treaty was made, but when settlers began arriving natives were pushed from their villages. Some tried to buy land, but Indians were not considered citizens and could not get titles to land. The 1884 Homestead Act finally allowed some tribal members to purchase land and become land owners. Those who bought land had to sever their ties to the tribe. It took additional legislation to establish the Lower Elwha Klallam Reservation in 1968. Members of the Lower Elwha tribe have worked to improve the life of its members with health, housing and job training. Most importantly—they have begun a major movement to revive the language and culture of the tribe and to share it with their neighbors.

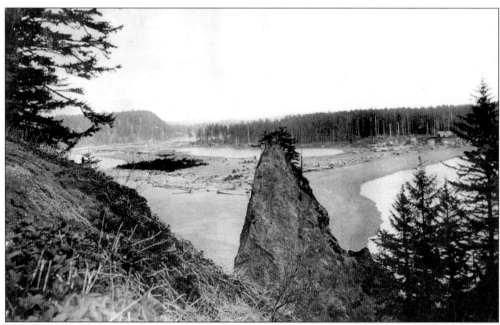

The Quillayute River enters the Pacific Ocean at LaPush. This view looks upstream toward the Olympic Mountains.

The Makah people have lived at the northwestern point in Clallam County for as long as anyone can remember. For thousands of years they hunted whales and seals and fished in the ocean waters. The Treaty of Neah Bay was signed with the Makah and Ozette people on January 31, 1855. Today the Makah are the only Native American people with the right to hunt whales and seals guaranteed by treaty. Commercial fishing is an important part of the economy of the tribe.

The Makah people were almost decimated during the 1700s when they first came in contact with diseases such as smallpox and tuberculosis. For years their children, like those on other reservations, were sent away to government schools and forbidden to engage in any of their cultural practices or to speak their native language. Problems have resulted, but today the Makah children and community take pride in their cultural heritage.

In the beginning there were five permanent villages in the Makah nation. Eventually the people moved into the community of Neah Bay where government services were available. The Ozette Reservation near Cape Alava was originally the home of a large whaling village covered by a mudslide hundreds of years ago. In the 1970s, the village was uncovered and archaeological discoveries made which have classified Ozette one of the most significant archaeological sites in North America. The findings of the ancient Ozette village are on display in the Makah Cultural and Research Center in Neah Bay.

The Quileute people originally lived on land which stretched from the shoulder of Mount Olympus to the Pacific ocean. They were included in the Treaty of Olympia whereby they also agreed to give up their traditional lands and move to a reservation. Because they were so isolated and because they did not want to leave the life they were used to, they did not move. In 1889 President Benjamin Harrison established a Quileute Reservation of approximately one square mile at LaPush at the mouth of the Quillayute River. Their culture was almost completely destroyed one summer when they were away and their long houses were burned to the ground with all of the tools and artifacts they contained. The village was rebuilt with "American style" individual houses and the elders continued to maintain their traditional crafts. One of the most important elements in Quileute culture is their distinctive language.

Settlements

There are three incorporated towns in Clallam County: Sequim, Port Angeles, and Forks. A number of small communities have come into existence over the years. Most are still recognized as geographic areas but with little or no evident sign of past history.

Before there was Sequim there was New Dungeness. The first permanent Euro-American settlement in what is now Clallam County began at New Dungeness about 1850 when American sea captains looking for timber to sell to California markets sailed into the Strait, landed, explored the land behind New Dungeness, and decided that it had possibilities. The Donation Land Act which gave up to 640 acres of land in the Oregon Territory absolutely free to settlers who arrived before December 1, 1855, was a great incentive.

Washington Territory was separated from Oregon Territory March 2, 1853. A year later, the first Washington Territorial legislature carved Clallam County out of Jefferson County. Whiskey Flat, a small trading post near the mouth of the Dungeness River below New Dungeness, became the first county seat for Clallam County. Within a few years residents who had created a small town on the New Dungeness bluff moved the seat of government. Elliott and Margaret Cline donated two lots for county buildings and for the next thirty years New Dungeness was the center of most commercial and political activity in Clallam County.

In 1890 government records were moved to Port Angeles and merchants realized that the channels into the bay were silting up and ships had difficulty getting into their port. They moved their town across the Dungeness River and created the town of Dungeness. New Dungeness ceased to exist.

In 1852 John Donnell, unable to find satisfactory land in New Dungeness and wanting more

elbow room, moved five miles up the Dungeness River to an arid prairie and took up his homestead. Others followed and somehow managed to make a scanty living in the community that became known as Sequim. The area is located in what is known as the rainshadow of the Olympic Mountains and averages fewer than 19 inches of rain a year. It was not until after 1896, when irrigation was brought to the valley, that Sequim began to grow.

Victor Smith is commonly known as the founder of Port Angeles. He had been appointed to the office of Puget Sound Customs Collector and Treasury Agent by President Abraham Lincoln in 1861. At that time, Port Townsend in Jefferson County was the Port of Entry and site of the Customs House for Puget Sound. Smith, for various reasons, decided to move the Customs House to Port Angeles, which had—he claimed—a better harbor, and was in a more strategic place to keep an eye on British activities at Esquimalt, the naval center on Vancouver Island. On June 19, 1862, in addition to an order removing the Customs House to Port Angeles, President Lincoln signed an order establishing a military and lighthouse reserve at Port Angeles harbor which effectively closed all land above high tide and one mile back to settlement. The following year congress passed the Townsite Act which declared that all federal land at portages, good ports, or other places suitable for settlement should be surveyed and sold at auction. Money raised was to go to support the Union Armies during the War Between the States. Smith persuaded the surveyor to only survey land four blocks back from the waterfront and to leave the remaining land in the Reserve. Between 1863 and 1890 only 85 people bought land in Port Angeles.

The town received a jolt in 1886–87 when the Puget Sound Cooperative Colony—an effort to establish a Utopian society where people could live together in peace and harmony in a cooperative setting and all residents would work toward common goals, receive free medical care, pay no taxes, and enjoy security—came to Port Angeles. Such goals as perfect unity and cooperation were difficult to achieve and the Colony eventually failed.

The Reserve was still a problem. When Port Angeles caught "railroad fever" there was no place for the city to grow. On July 4, 1890, residents "jumped the Reserve" and squatted on two lots apiece, meanwhile asking Congressman Wilson to get a law passed which would open the Reserve and give them title to their lots. A number of Civil War veterans came to Port Angeles for free land. The Reserve was opened January 1, 1894.

Port Angeles continued to grow. At one time it had five working mills, a thriving international lumber trade, and a busy commercial and tourist fishery.

In 1878 Luther Ford and his family, looking for a likely place to homestead, moved to a grassy prairie twelve miles inland from LaPush on the Quillayute River. Before long others came to join them and a community began to develop. Ford bought a herd of cattle and had them brought to Neah Bay on a little schooner. Because it was difficult to ferry cattle down the coast in Indian canoes, he herded them overland and along the beach to his farm. In addition to building a creamery, nearby farmers grew hops and peppermint. Later a sawmill was built. When it came time to name the town, the name was chosen because three nearby rivers—Sol Duc, Calawah, and the Bogachiel—forked to create the Quillayute River. Eventually a road was built between Clallam on the Strait and Forks. By 1890 Forks had a general store, post office, newspaper, saloons, school, and hotel. Electricity became available in 1923. In 1951 the town was almost destroyed by a fire that burned over 35,000 acres of nearby forest land. Although Forks holds the dubious distinction of having one of the highest rainfalls in the United States, it remains a center of forestry activities and is beginning to capitalize on tourism.

Today visitors to the Olympic Peninsula can drive the US Highway 101 loop and visit all three cities while enjoying the beauties of the Olympic National Park and the varied landscape and climates of Clallam County.

One

THE LAND

The Pacific Ocean meets the Strait of Juan de Fuca—a welcome sight for early sailors.
Vancouver Island, Canada, is in the distance.

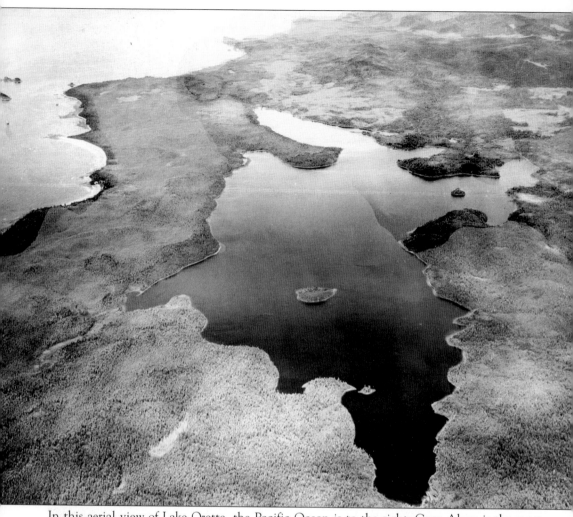

In this aerial view of Lake Ozette, the Pacific Ocean is to the right; Cape Alava is the most westerly point of the contiguous United States. Off in the distance Cape Flattery extends beyond the Point of Arches. Most of the land shown is in the National Park.

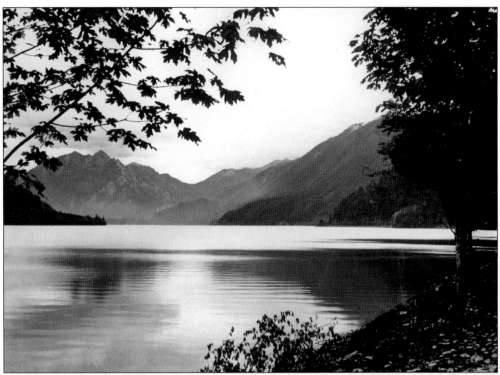

The still waters of Lake Crescent can change in a hurry. Mt. Storm King rises in the distance.

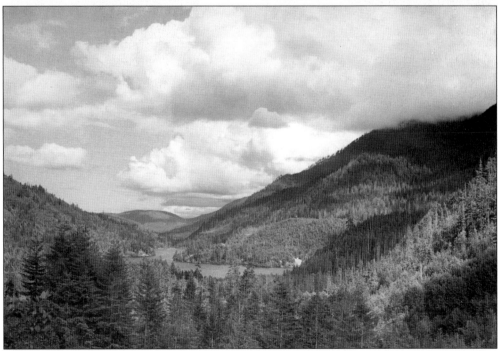

Lake Sutherland, east of Lake Crescent, may have been created by a gigantic landslide which forever separated the two.

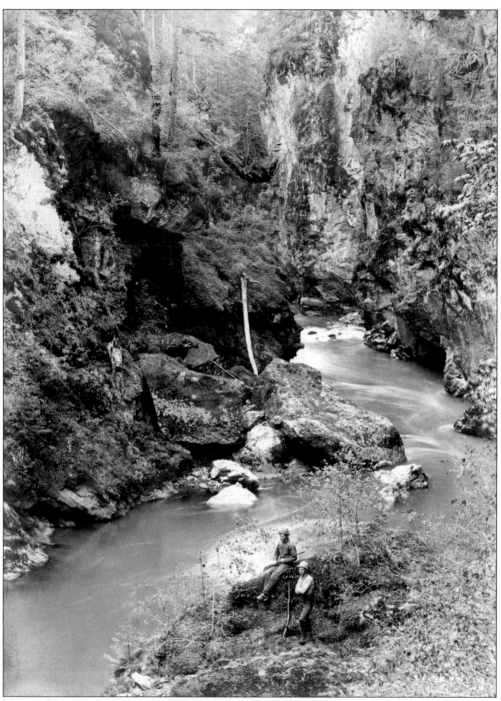

This good fishing spot in the Elwha River Canyon was covered with water when Thomas Aldwell built his first dam on the river.

A lower Olympic National Park trail to Humes Ranch runs through Krause Bottom at the edge of the Elwha River.

Freshwater Bay, west of Port Angeles, hosts one of several county parks on the Strait of Juan de Fuca.

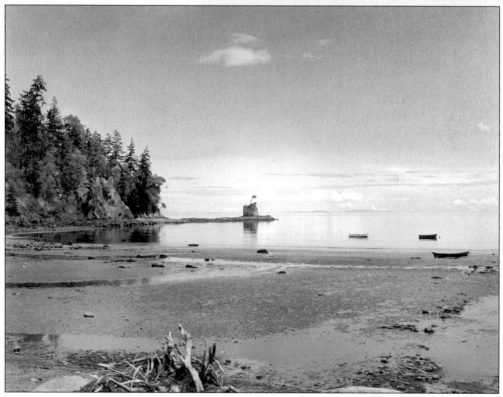

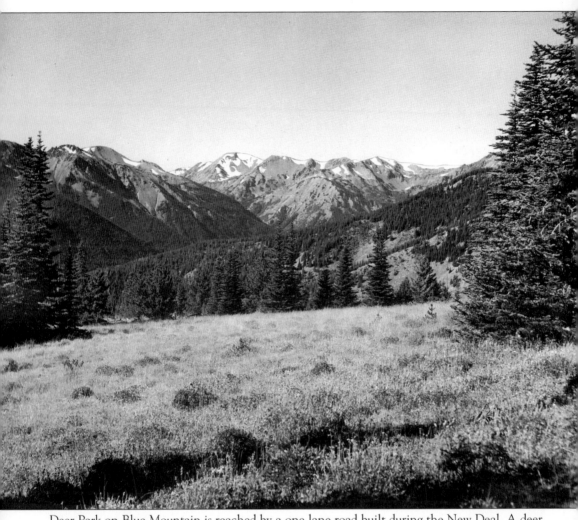

Deer Park on Blue Mountain is reached by a one lane road built during the New Deal. A deer has just stepped behind the trees on the left.

Two

NATIVE AMERICANS

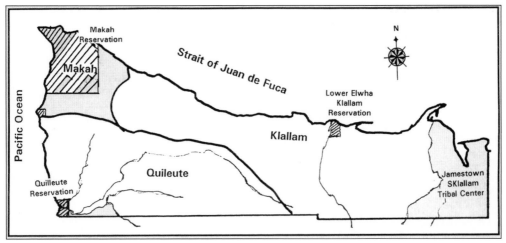

This map identifies the location of traditional Indian lands before the treaties were signed, as well as the reservations or land the tribes have now.

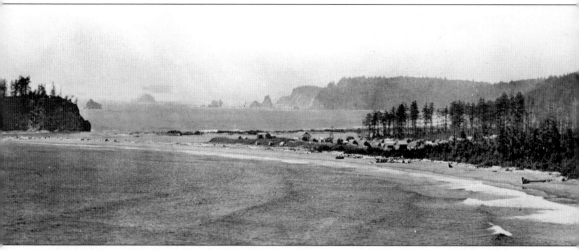

This aerial view looks north along the Pacific Ocean with LaPush village and James Island in the foreground. This part of the Pacific coast is known as the "Shipwreck Coast."

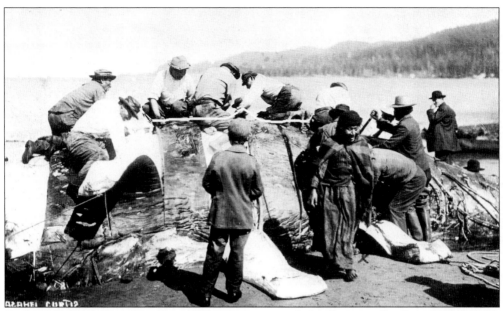

Quileute Indians are pictured in 1900 cutting up a whale. Gramma Smith and William B. Mahone are in front.

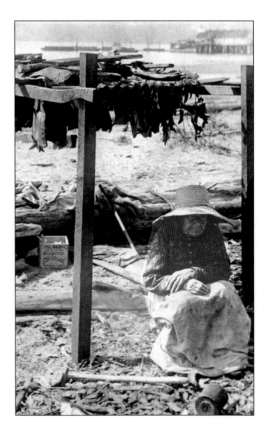

Gramma Smith was photographed beside a fish rack with fish hung up to dry for winter use.

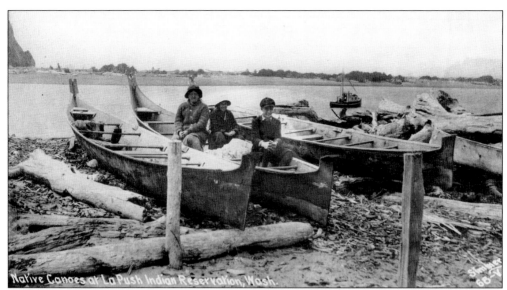

Quileute Indians are pictured at the mouth of the Quillayute River with their canoes. Rialto Beach is in the background.

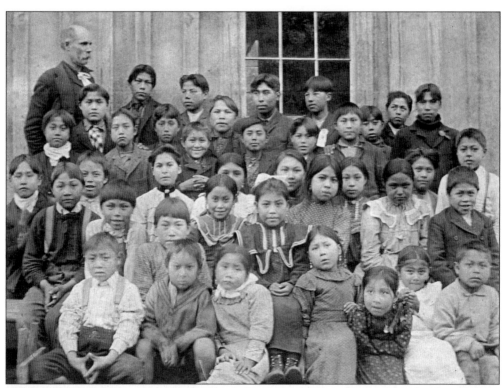

The Indian Agency sent Alan Wesley Smith (back row, left) to be the first school teacher on the Quileute reservation. He gave the Native students American names such as William Penn, George Washington, and Abraham Lincoln.

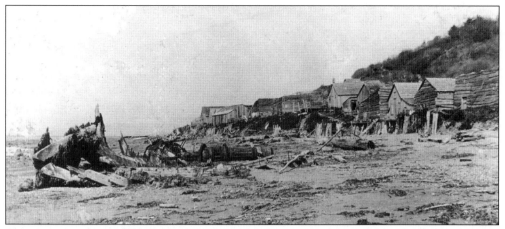

The Ozette Indian village at Cape Alava was deserted in the 1930s. The remains of the shipwreck *Austria* are pictured in the foreground.

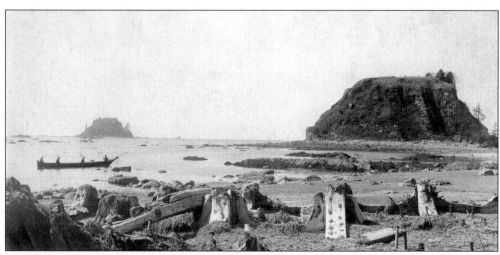

The Ozette village looked out at the ocean. Badelith Isle is on the left; "Cannonball Island" on the right was a sacred place. During World War II the US government built a coastal lookout there.

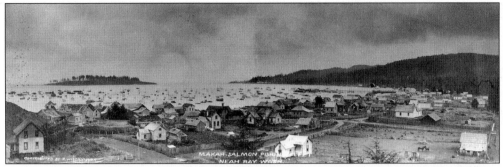

The Makah fishing fleet sat in the harbor at Neah Bay about 1900. For years it was the fisheries capital of the county with up to 600 trolling boats operating in the seasons of the 1950s and '60s.

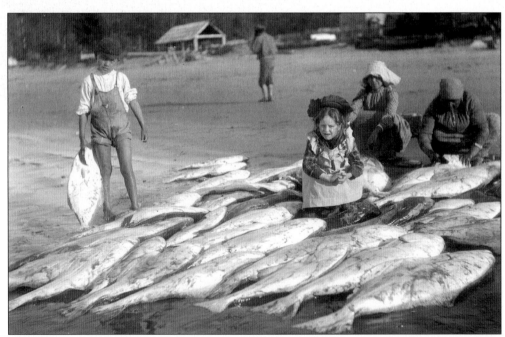

The Makah were photographed showing off a large halibut catch on the beach.

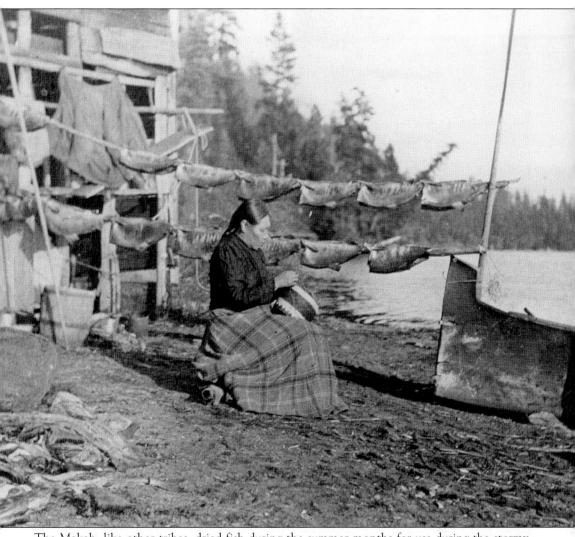

The Makah, like other tribes, dried fish during the summer months for use during the stormy winter months. A woman weaving a basket sat beside the fish racks.

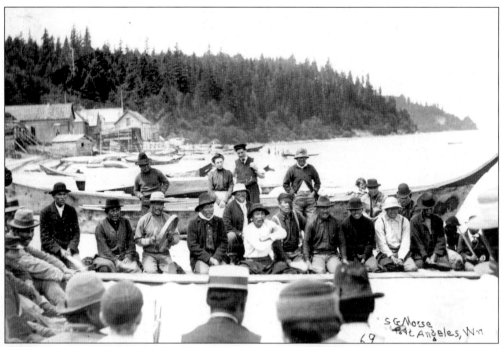

Members of the Makah tribe posed with a large canoe around 1890. Chief Peter Brown (man with his arms crossed) is in the center of the picture.

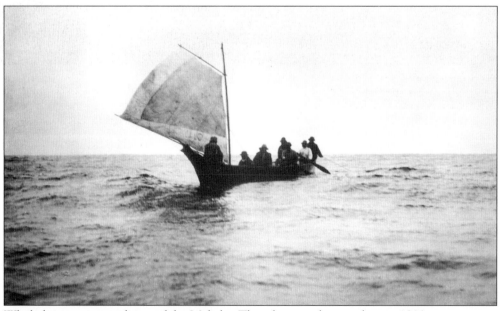

Whale hunting is a tradition of the Makahs. This photograph was taken in 1910.

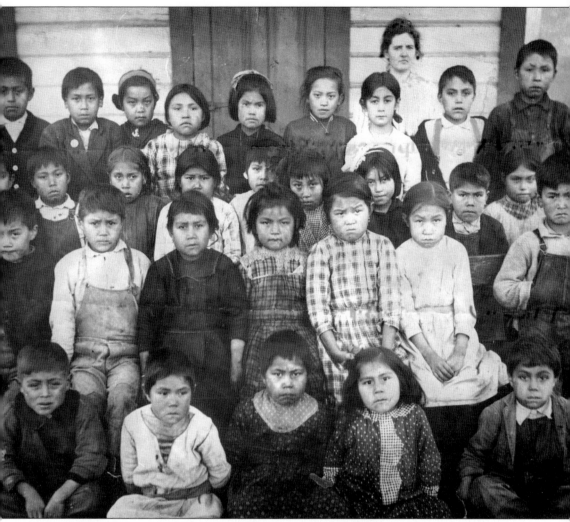

Many Makah children were sent off the reservation to go to boarding school, but eventually a reservation school was established. The children were not allowed to speak their native language in school. The children in the photograph were not identified.

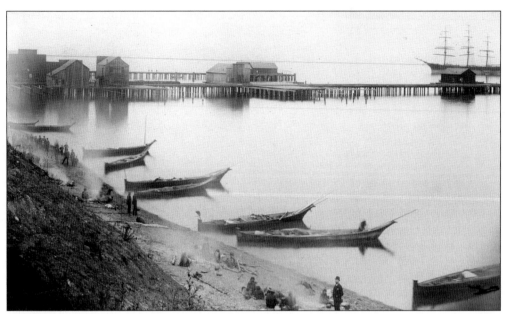

The Klallam Indians had at least ten villages along the coast between the Hoko River and Port Townsend. This camp was probably at Hollywood Beach in present Port Angeles.

Some Klallam Indians refused to leave their traditional lands to move to a reservation. Eventually the S'Klallams pooled their money and, under the direction of Chief Jake Hall, bought land at Jamestown. This is the Shaker Church of the Jamestown S'Klallam tribe.

Three

THE EAST END

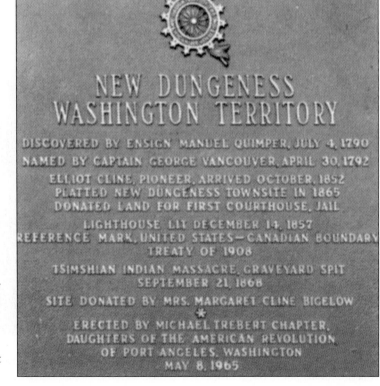

A memorial was erected in 1965 by the Michael Trebert DAR Chapter to identify the location of the first town in Clallam County, New Dungeness. The small park is at the corner of Marine Drive and Clark Road overlooking the Strait of Juan de Fuca.

NEW DUNGENESS
WASHINGTON TERRITORY

DISCOVERED BY ENSIGN MANUEL QUIMPER, JULY 4, 1790
NAMED BY CAPTAIN GEORGE VANCOUVER, APRIL 30, 1792

ELLIOT CLINE, PIONEER, ARRIVED OCTOBER, 1852
PLATTED NEW DUNGENESS TOWNSITE IN 1865
DONATED LAND FOR FIRST COURTHOUSE, JAIL

LIGHTHOUSE LIT DECEMBER 14, 1857
REFERENCE MARK, UNITED STATES – CANADIAN BOUNDARY
TREATY OF 1908

TSIMSHIAN INDIAN MASSACRE, GRAVEYARD SPIT
SEPTEMBER 21, 1868

SITE DONATED BY MRS. MARGARET CLINE BIGELOW
*
ERECTED BY MICHAEL TREBERT CHAPTER,
DAUGHTERS OF THE AMERICAN REVOLUTION
OF PORT ANGELES, WASHINGTON
MAY 8, 1965

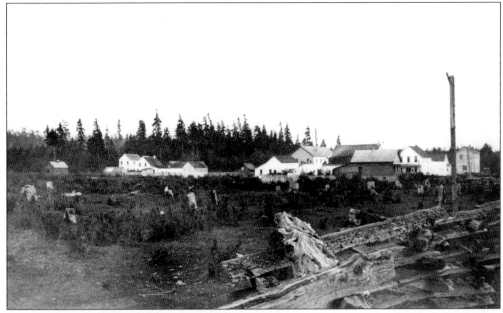

New Dungeness was an impressive collection of buildings by the mid-1870s. The first county courthouse, the two-story white building on the left, was erected in 1865 on land donated by Elliott and Margaret Cline. Other buildings included a store, hotel, post office, livery stable, saloons, and residences.

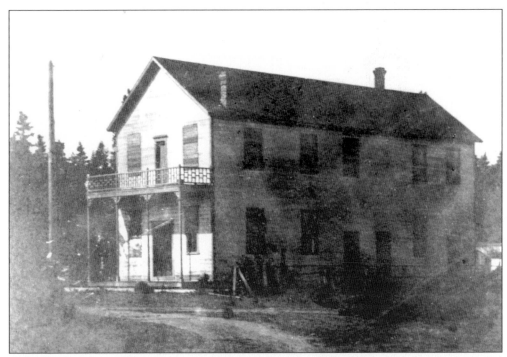

Travelers stayed at the New Dungeness Hotel while they conducted their business in town and waited for the next steamer. This is one of the very few photographs of individual buildings. (Bert Kellogg Collection.)

William King was the first school teacher in School District No. 1 Clallam County. (Courtesy of Robert Clark.)

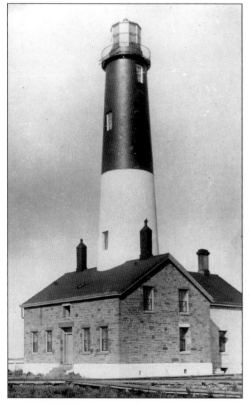

The New Dungeness Lighthouse was lit December 14, 1857, the first on the south side of the Strait of Juan de Fuca. Originally 90 feet tall, the tower cracked and was later lowered to 70 feet. Today the lighthouse is maintained by volunteers of the New Dungeness Lighthouse Society.

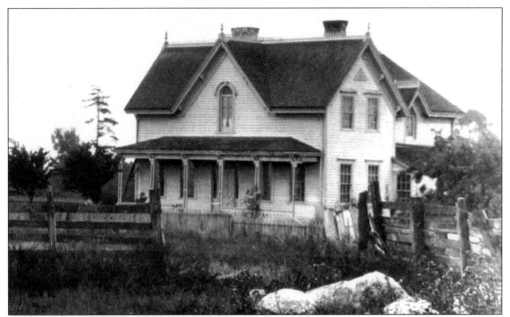

Elijah McAlmond, a sea captain, built the first house in the county made of real lumber, lathed and plastered inside. McAlmond was one of the first county commissioners and later served in the Territorial Legislature. The restored McAlmond House was placed on the National Register in 1976.

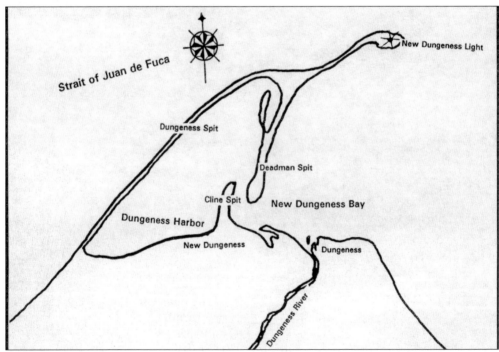

This map locates the sites of the towns of New Dungeness and Dungeness. Other geographic features include Dungeness Spit, Cline Spit, Deadmans Spit, Dungeness Bay, and the Dungeness River. The earliest settlements in Clallam County were made in New Dungeness.

A tall forest covered the Dungeness area at one time. This view is looking south along Woodland Way. Fields and housing developments have replaced the forest.

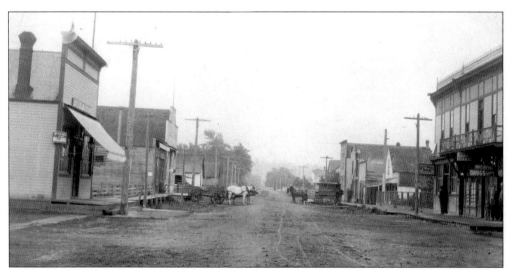

In 1890, when the channels around the spits into the bay began to fill in, New Dungeness merchants purchased land on the east side of the river and moved their buildings and businesses one mile to the east. Woodland Avenue became the main street of the new town.

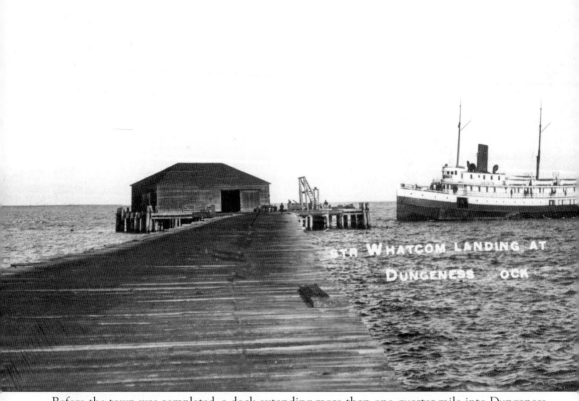

Before the town was completed, a dock extending more than one-quarter mile into Dungeness Bay was constructed. This view shows the steamer Whatcom unloading goods and passengers. Later a railing was built along the dock. All that remains of the long dock today is a double row of pilings stretching into the bay.

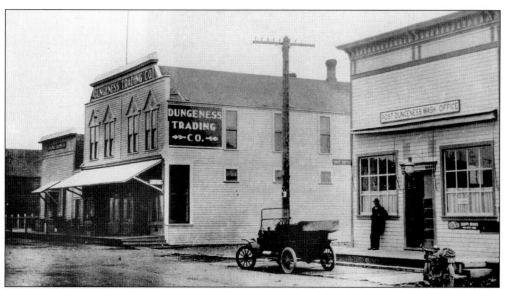

C.F. Seal's Dungeness Trading Company was one of the first and biggest businesses in the East End by 1903. It was said that if Seal did not have what you wanted in stock, it would be in the store next week. A meeting room occupied the second floor.

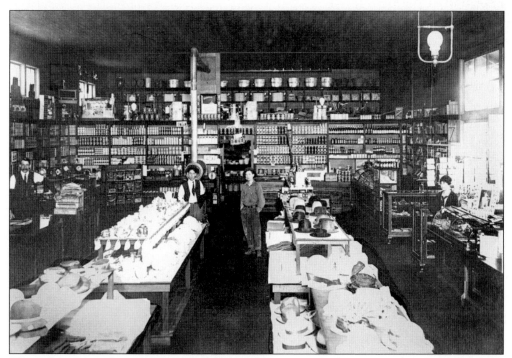

The wide variety of merchandise available to customers in Seal's store can be seen in this view of the interior. (Bert Kellogg Collection.)

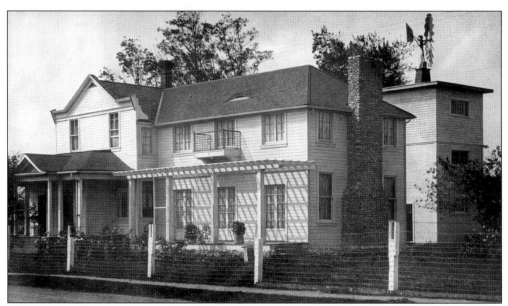

Seal built an elaborate "mansion" which he named "Groveland." It featured a ball room and a sunken rose garden. Today it is a bed and breakfast known as Groveland Cottage.

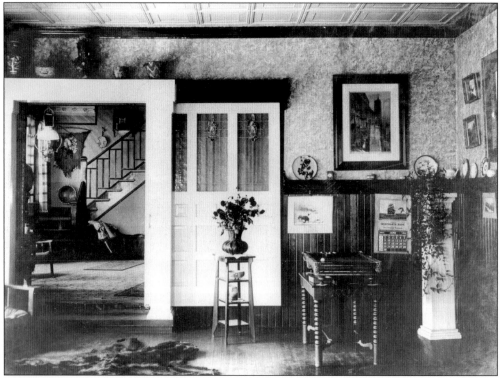

The Victorian interior of the parlor in the C.F. Seal home was more elaborate than that of many of his neighbors. Notice the glass sliding door and the pool table.

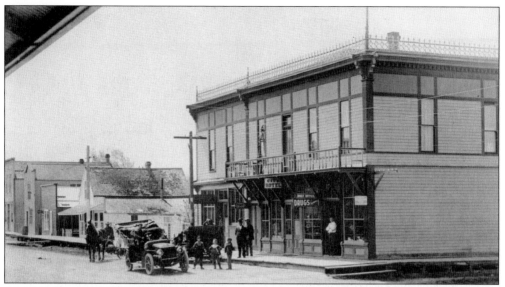

Competition for shoppers' dollars resulted in the construction of several other general stores. This was Billy Monson's store, across the street from Seal's. Hotel rooms were available above the store.

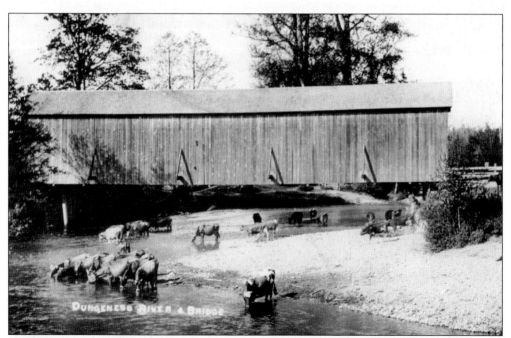

A covered bridge was built across the Dungeness River just south of town to provide access to the road to Port Angeles. That road had been built earlier to connect the county seat at New Dungeness with Port Angeles.

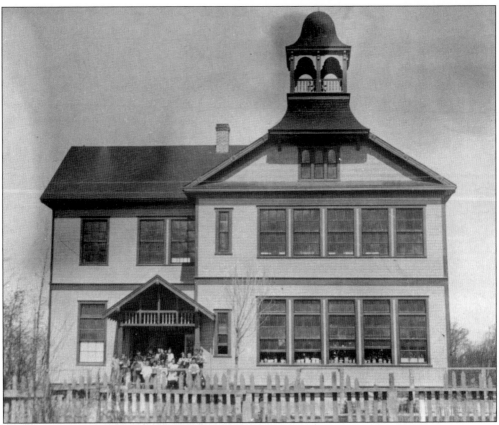

To meet the greater needs of many families who moved to Dungeness, the two-story Dungeness School was built in 1892 east of the river. For years it was the only rural school to offer classes from the first grade through high school. No longer used as a school, it was placed on National Register in 1988.

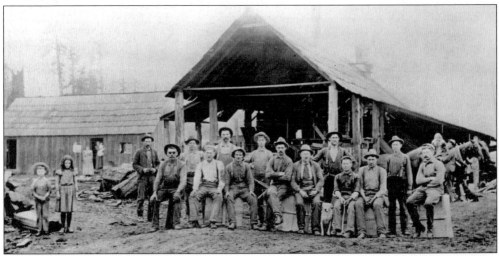

By 1900 the Dungeness Shingle Mill was providing jobs for many of the townspeople. The women in the back worked in the cook shack.

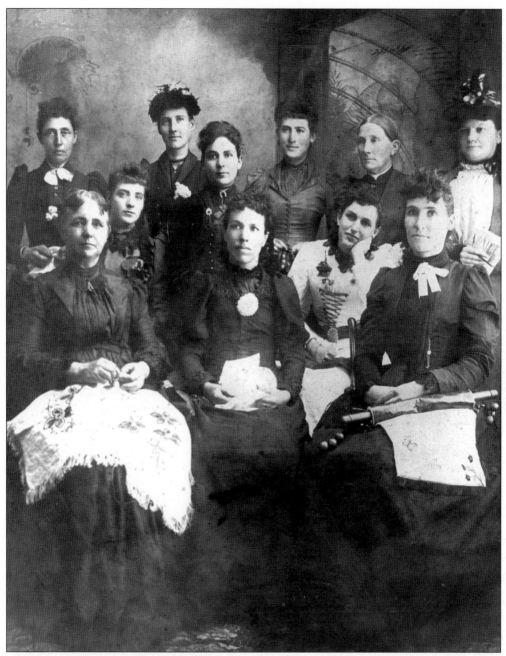

Cultural activities were important. The Methodist Ladies' Aid Society was one of the oldest organizations in the Dungeness Valley. Pictured from left to right are: (seated) Mrs. A.A. Davis, Annie Davis, Mrs. Kindred (wife of the minister), Bessie Minor, and Mrs. William Ward; (standing) Mrs. George Alexander, Mrs. A.L. Wild, Florence Mann, Mrs. J.H. Lepsett, Mrs. Hall Davis, and Mrs. Will Church.

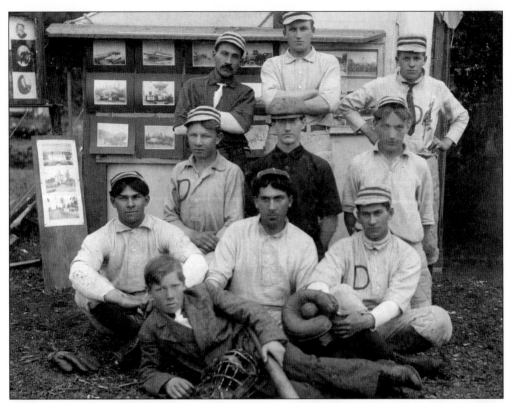

Dungeness was famous for its sports teams. This prize winning baseball team probably competed with teams as far away as Georgetown and Tacoma.

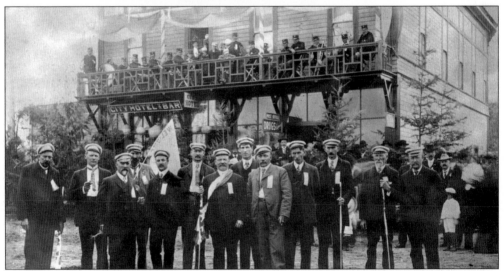

The Elks "Round up" in Dungeness in August 1903 brought Elks from around the county to the celebration. Picture from left to right are Fred Ward, George Davis, Wint Thompson, George Lutz, Jim Dick, Ham Lipsett, Jack Wilcox, Mel Rogers, Axel Wall, Norman Govan, Frank Lotzgesell, Captain Hansen, and Hans Bugge. The Fort Warden Band is on the hotel balcony. (Bert Kellogg Collection.)

Other communities began in the East End along the Strait. Washington Harbor, at the entrance to Sequim Bay, became the center of a food canning operation. Hans Bugge's elaborate home sits to the right of the photo at the base of the hill.

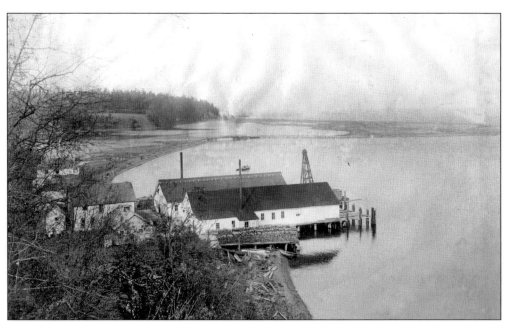

Bugge's Cannery is now the site of Battalle Northwest, a research organization. For years, ships of the mosquito fleet stopped here. Passengers who disembarked at Port Williams crossed the bridge over the lagoon to Washington Harbor to access the road to Sequim.

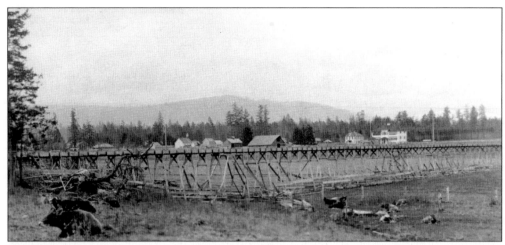

The Sequim prairie was irrigated beginning in 1896. This photo shows the flume carrying water from the Dungeness River across the Sequim prairie to the Port Williams Ditch District. (Courtesy of Sequim Museum and Arts Center.)

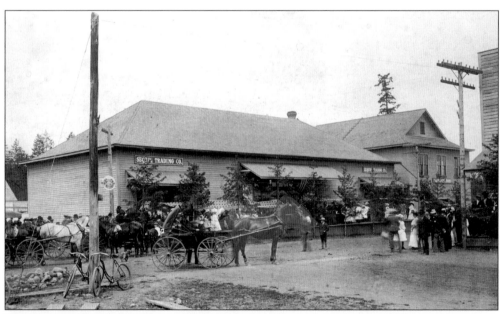

The Irrigation Parade brought out the crowds along Sequim Avenue in 1907.

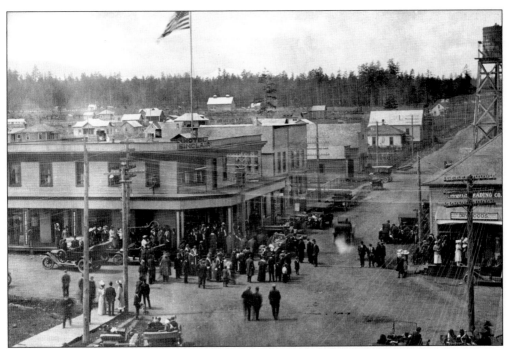

A 1911 Fourth of July parade in Sequim lined up at the intersection of Sequim Avenue and Washington Street. The building on the left was the Sinclair Hotel. Seal's Sequim Trading Store is at the right.

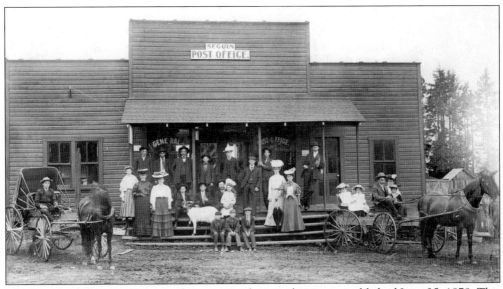

The first post office in Seguin, as the town was known then, was established June 25, 1879. This is the second post office. The name was changed to Sequim in 1907.

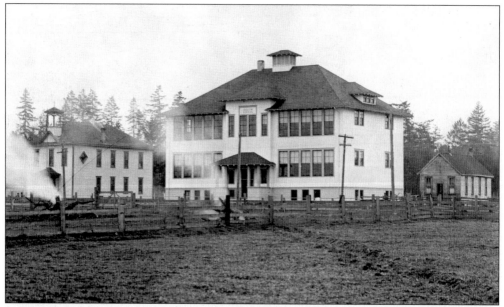

By 1868 the 16 families with children had decided they needed a school for their children. This photograph shows the first three schools built in Sequim. The first one-room 1869 school house is at the left rear, a later, small, two-story school is at the right. The large eight room building was erected in 1911.

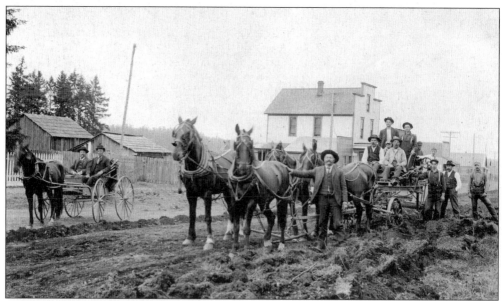

As Sequim grew, businesses were built along Washington Street. These men, many wearing suits and ties, were photographed during the grading of Washington Street. The men in the buggy are E.J. Huff and Hans Bugge. The man holding the horse is J.B. Knapman.

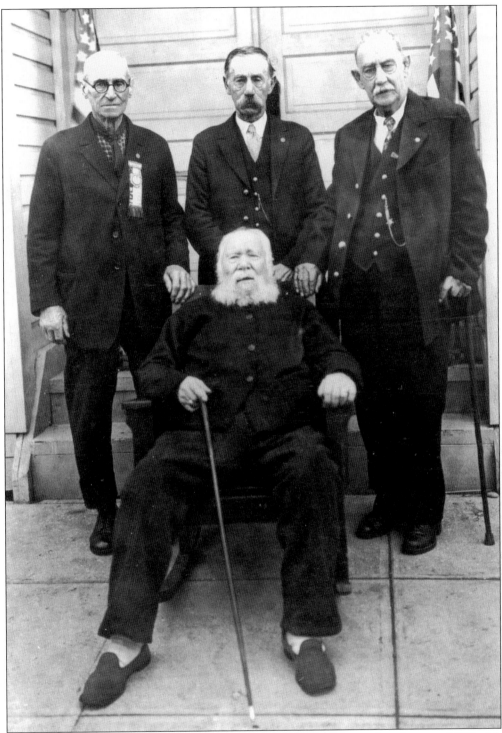

Matthew Fleming, a veteran of the Indian Wars of 1855, was pictured at the age of 100 with veterans of the Civil War in front of the GAR Hall. Standing from left to right are Chris Miller, Philo P. Gallup, and Bill Green. (Courtesy of the Sequim Museum and Arts Center.)

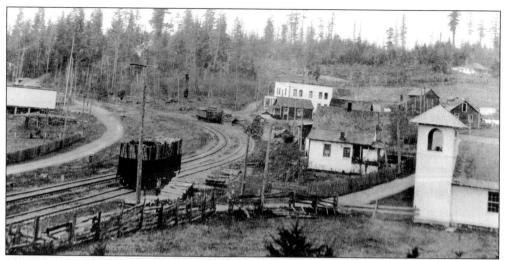

The community of Blyn began at the head of Sequim Bay after 1900. Town industries included a log dump, several mills, and a cannery. After 1914, when the railroad was built, part of the town was demolished to make way for the tracks. Buildings remaining included the Grand Hotel, tavern, and church when this picture was taken.

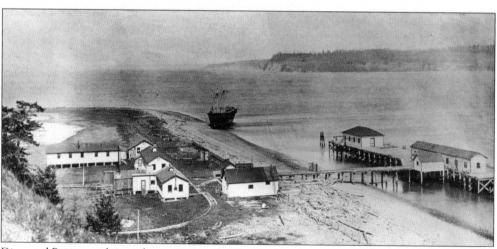

Diamond Point, on the northeast corner of Miller Peninsula, was established as a US Quarantine Station in 1893. The ship on the beach is the hulk of the *USS Iroquois*, a steam schooner that saw action in the Civil War. She ended her career as an immigrant quarantine station.

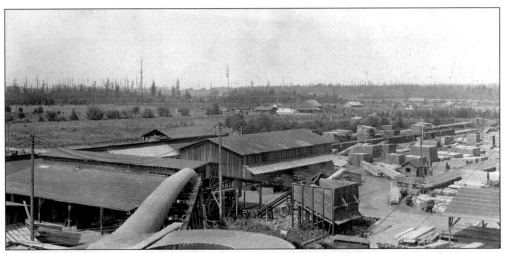

Carlsborg replaced the earlier community of Rena when C.J. Erickson built the line that became the Milwaukee, Chicago, and St. Paul Railroad from Port Townsend to Port Angeles and named the mill town for his home town of Karlsborg in Sweden.

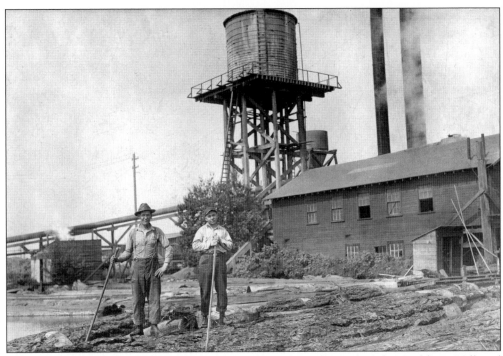

John Soderberg (left) and Walt Johnson posed on the mill pond of the Carlsborg Mill and Timber Company in the 1920s. The mill pond has since been filled in and the mill site is now an industrial park.

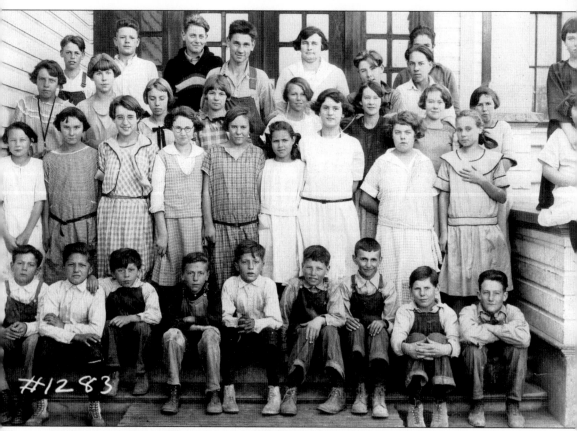

Students in grades 5, 6, 7, and 8 at the Carlsborg school in 1920–21 gathered together on the front steps of the school for their annual photograph. Miss Ware, in the rear, was the teacher.

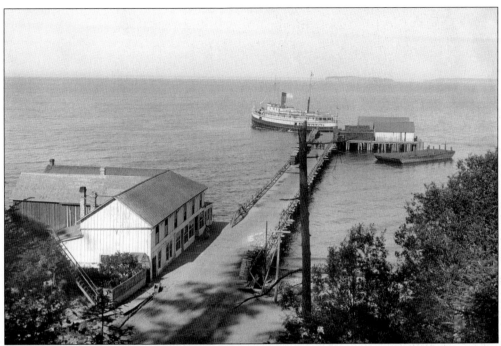

Although Port Williams was platted in 1892, the dock with its large hotel, restaurant, and general store was not built until 1890. The second post office there was established in 1890 and continued until 1919. It vied with Dungeness as the Port of Entry for Sequim and the East End.

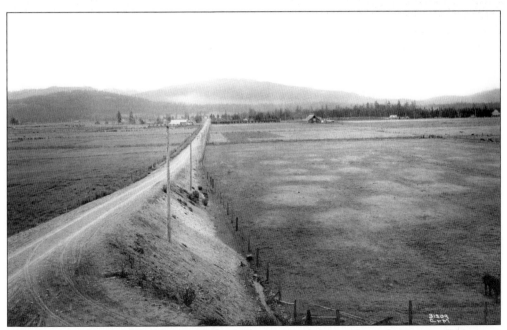

This is a general view of the Sequim Valley looking toward the south on the Sequim-Dungeness Road. The town is beyond the trees which have been planted on the prairie. (Courtesy of the Washington State Historical Society.)

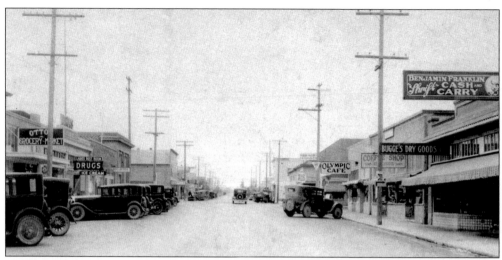

Washington Street became the main street of town when US Highway 101 was built. This view looks west. The picture was taken before the power poles were moved to the alleys.

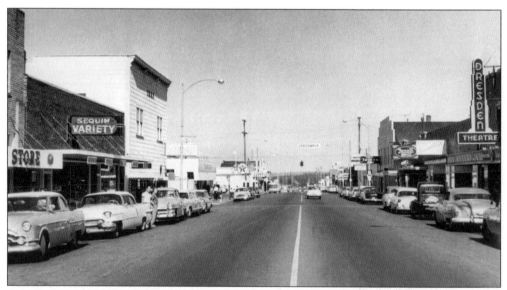

During the early 1950s, the first stop light was placed at the intersection of Sequim Avenue and Washington Street. Drivers were cautioned to wait for the light to turn. The Dresden Theater on the right is now the Gazette Building. This view looks east.

Four

PORT ANGELES

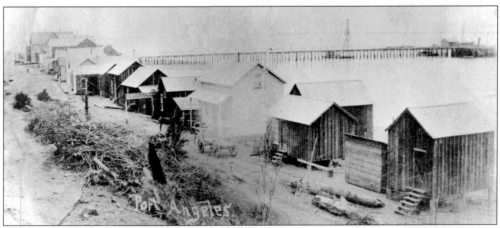

First Street in West Port Angeles was a motley collection of wood buildings along the beach in 1886. It is no wonder that when the Puget Sound Cooperative Colony (PSCC) arrived it selected a site almost a mile away.

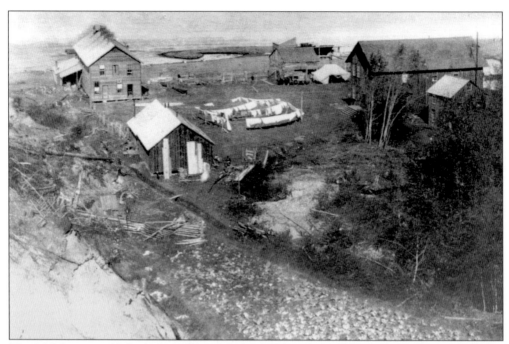

The PSCC was established in east Port Angeles at Ennis Creek. The large building on the right was the first building (hotel) built to provide housing for the earliest Colonists.

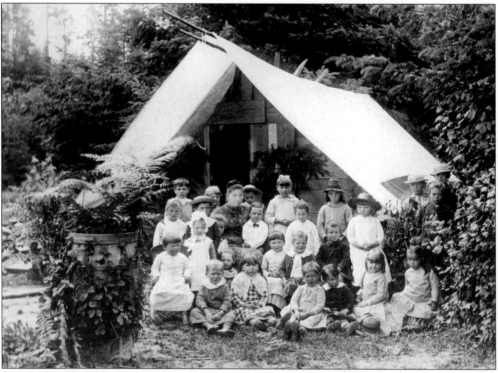

The PSCC established the first kindergarten in Clallam County in 1887. Classes were taught in a tent-roofed building.

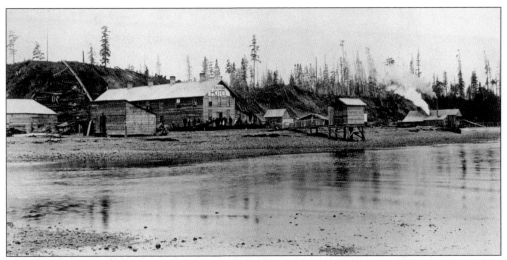

By 1887 Colony buildings included a saw mill, a ship yard—not shown—and many homes. The small buildings on pilings were restrooms. When the tide came in they were flushed.

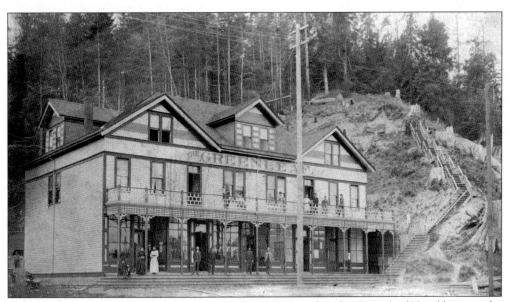

In 1890 when county government was moved to Port Angeles, the Greenleaf Hotel became the second county "courthouse." It was destroyed in a fire in 1889, but county records were saved.

The Opera House, built in 1891 on Front Street (replaced later by the Kirschberg Building), was constructed by Colony carpenters. It was demolished in 1923.

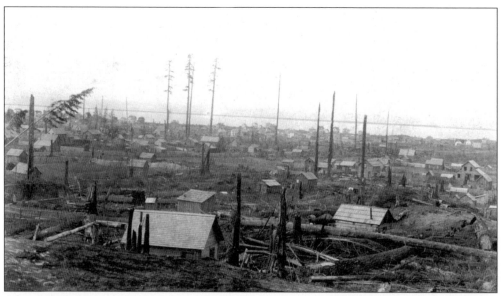

After 1890, when the Reserve was opened, houses arose among the stumps and snags. Each squatter could claim two lots, one to build a house on, and one to improve.

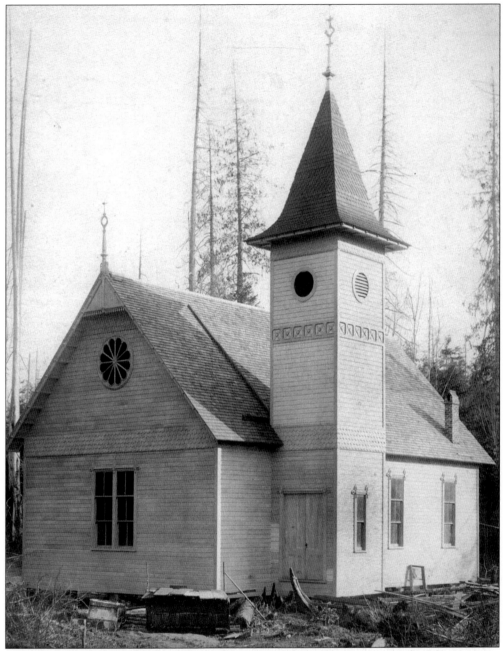
The First Congregational Church building on First Street is one of several churches built by Colony carpenters. Although it is no longer used as a church, it is still recognizable.

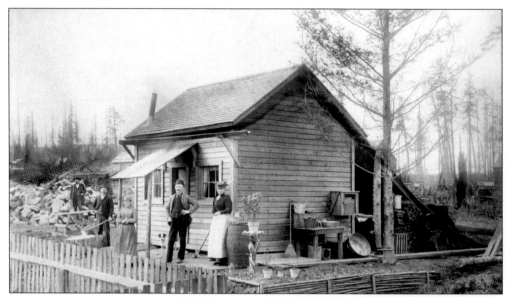

This small home is typical of the Reserve homes. Notice the wood pile under the lean-to and the attempt to beautify with flowers.

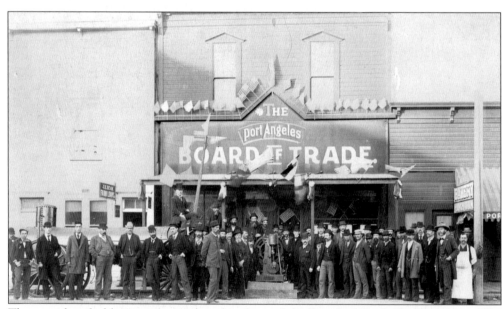

These unidentified businessmen gathered in front of the Board of Trade Building for a group photograph in the 1890s.

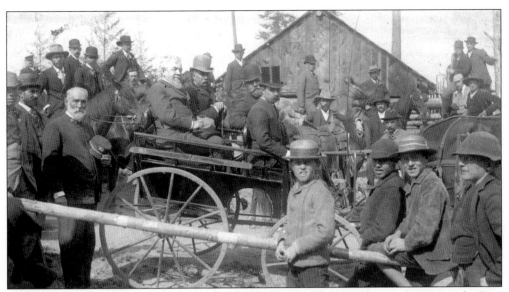

In 1892 Secretary of the Interior John W. Noble (hatless man seated in cart) came to the Port Angeles townsite reserve to inspect and dedicate 40 blocks on Lincoln Heights reserved for Civil War veteran members of the Michigan Soldiers Colony.

John G. Bank was one of the more than one hundred Civil War veterans who settled in the Port Angeles townsite.

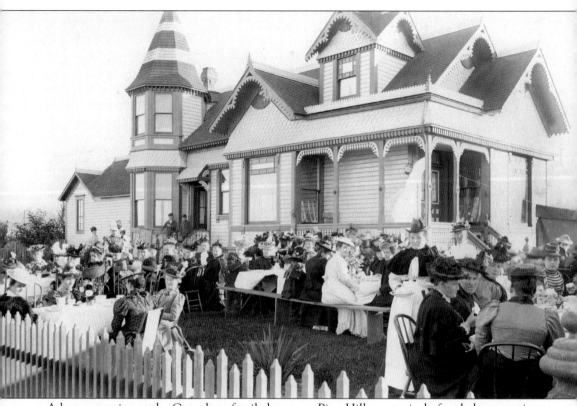

A housewarming at the Gutenberg family home on Pine Hill was typical of early large parties.

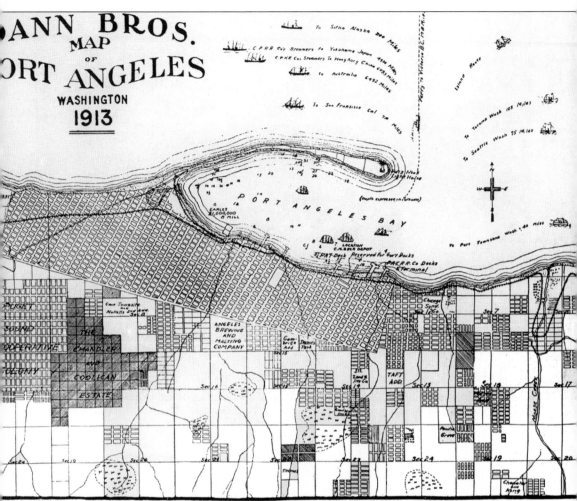

PORT ANGELES, WASHINGTON

The Greatest Future Shipping Port of the Pacific Coast

The Coming Coast City

The Natural Terminus of all TRANSCONTINENTAL ROADS North of California

This 1913 Dann Bros map of Port Angeles shows the Reserve land north of the "diagonal" Lauridsen Boulevard and the ten acre lots open to development outside of the Reserve.

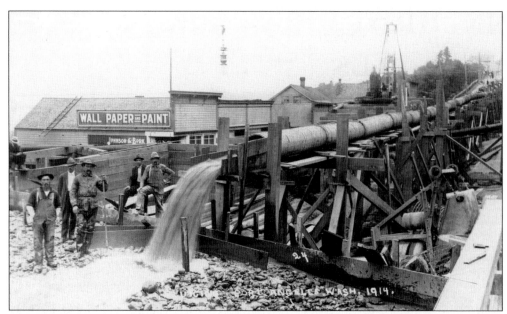

Port Angeles city officials decided to sluice the hills around town to make it easier to get down to the business area and to raise the street level above the beach. This 1914 photograph shows the sluicing of Front Street hill at Lincoln Street.

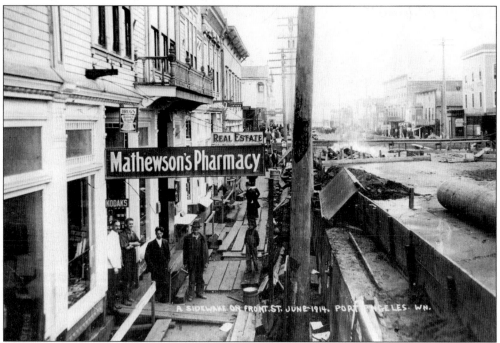

To raise the street level, walls were built along the sidewalks to allow access to businesses while slurry was being pumped behind the dams. At the same time owners either raised their buildings to the new street level or built additional stories. The Port Angeles underground was the result.

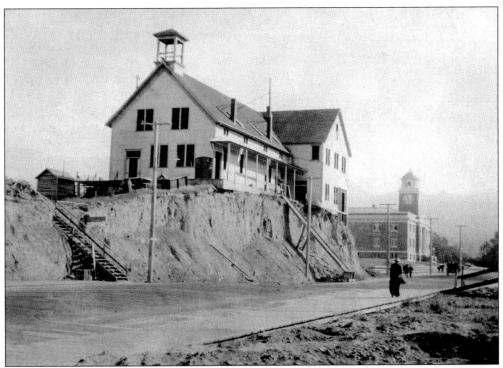

After the Lincoln Street hill had been cut away and a new courthouse built, city employees slid records down a slide from the old (4th) courthouse on the hill to street level and carried them to the new courthouse.

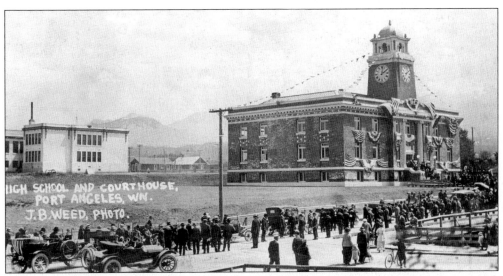

This photograph was taken at the dedication of the Clallam County Courthouse in 1915. Roosevelt High School, behind the courthouse, has since been removed. Notice the planking over the ravine on Lincoln Street.

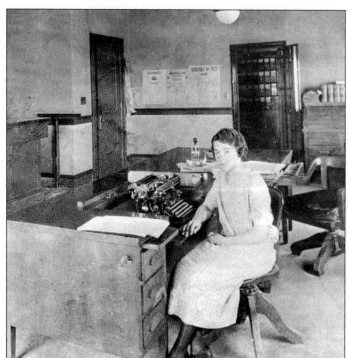

(*left*) Willie White, deputy clerk, posed for her photograph in the second floor Clerk's Office in the new courthouse.

(*opposite page*) The first new Ford was delivered to the County Extension Service in 1928. Mrs. Harriet Shaw, in charge of Home Demonstration work and A.W. Holland, Agriculture Agent, received the car.

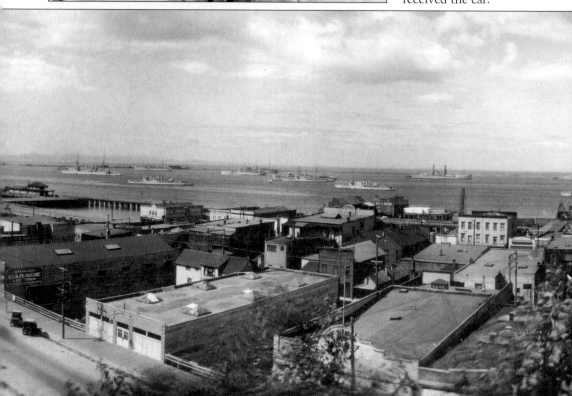

The US Pacific Fleet, which visited Port Angeles harbor every summer for almost 40 years

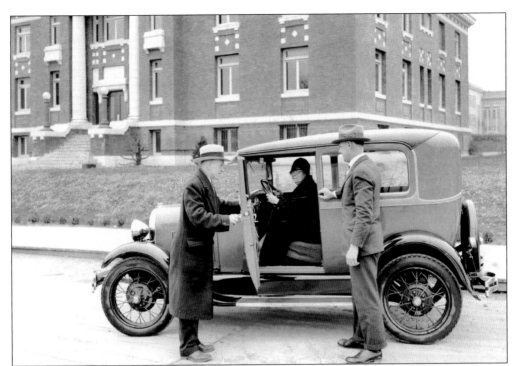

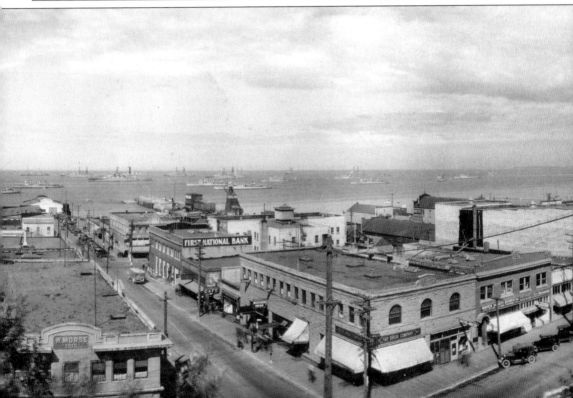

beginning in 1896, brought more than 50 ships to the harbor in 1926.

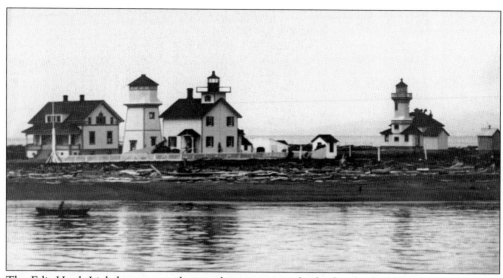

The Ediz Hook Lighthouse complex on the spit across the harbor looked like this in the early part of the 20th century. It was first lit in 1864.

Young Thomas Aldwell came to Port Angeles from Belleville, Canada, in 1890. He became a leading businessman involved in a number of ventures including real estate.

Businessmen gathered at the First and Laurel corner of the Aldwell Building outside the Citizens National Bank. The first three men on the left are unidentified. The remaining two are Conrad Lupper and J.P. Christensen (bank manager).

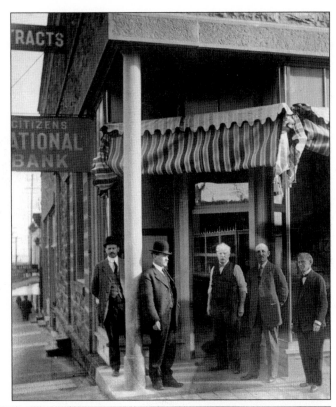

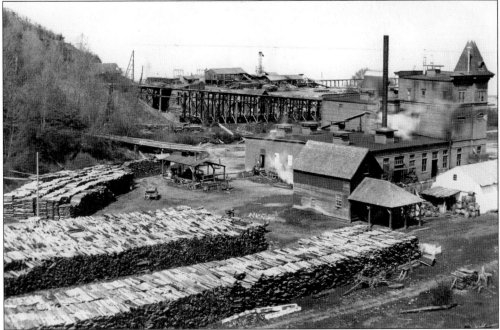

The Port Angeles Brewing and Malting Company at the foot of Tumwater Street was the scene of much activity from 1902 when it was built until prohibition. The company had its own boat to transport products to Seattle.

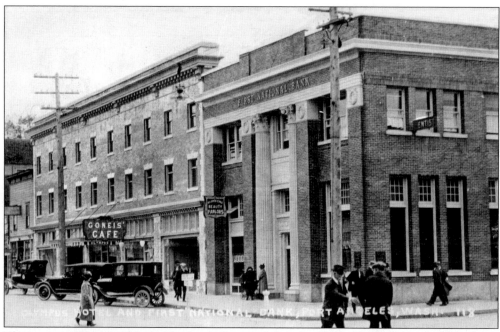

The corner of Front and Laurel looks much as it did in the 1920s. Only the name of the bank has changed. The Olympus Hotel next door was destroyed after a gas stove, in what by then was Haguewood's Cafe, exploded in 1971.

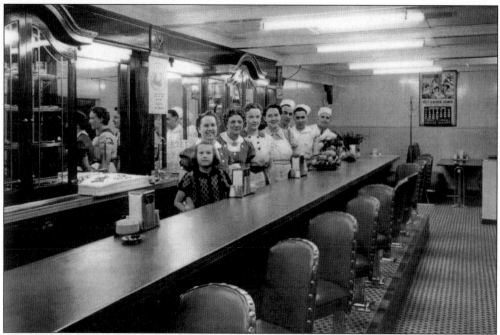

Club Cafe, a popular restaurant, operated in the basement of the Aldwell Building. Staff, from left to right, included Gladys Snodgrass (ten years old), Ethel Snodgrass, Neola H(?), Margaret Smith, Julia Hawley, Anton Beeman, Romney Macklin, and Lloyd Snodgrass. (Courtesy of Gladys Snodgrass Kendall.)

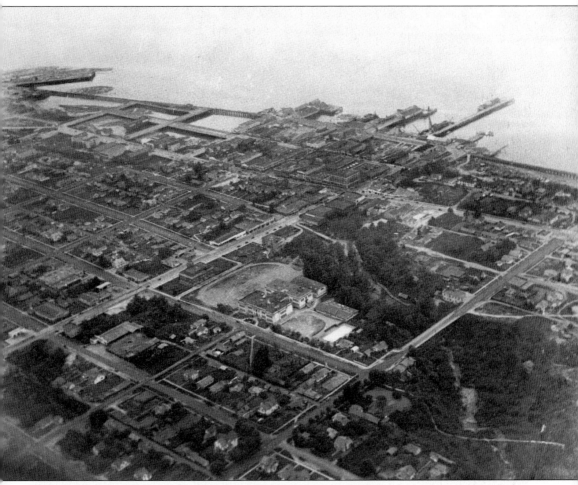

This aerial view of Port Angeles features Roosevelt High School in the center of the photograph behind the courthouse. Peabody Creek meanders under the wooded area. Railroad Avenue was later built behind a bulkhead where the railroad trestle runs along the waterfront.

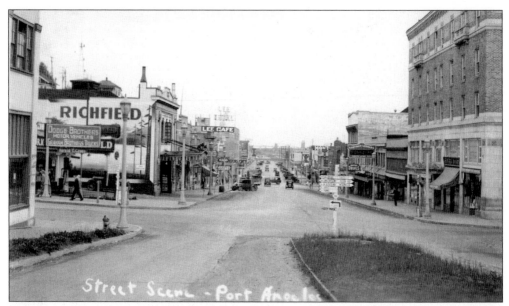

First Street became part of US Highway 101, which turned south at Lincoln Street instead of going directly through the business district. A median separated east and west traffic. The Elks building is at the right intersection.

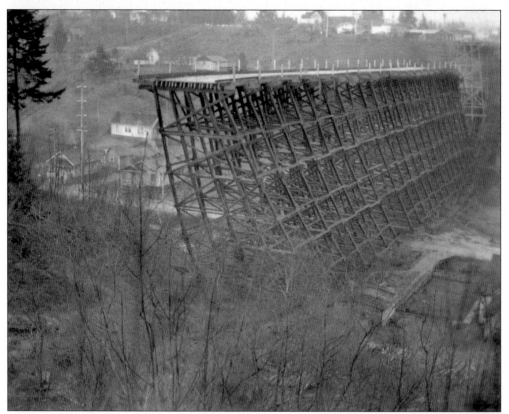

Street improvements included new bridges across the Valley Street and Tumwater ravines.

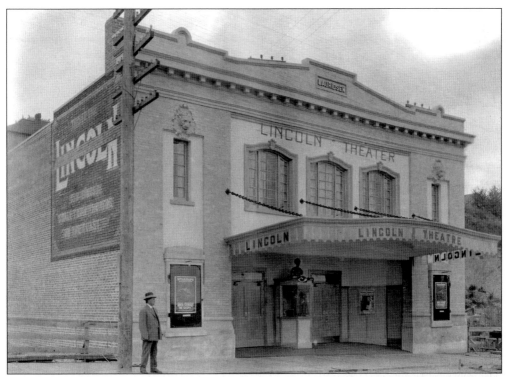

The Lincoln Theater opened for its first performance on First Street near Lincoln in September, 1916. It was said to be the finest small theater on the Pacific coast and featured a Kimball Symphony Orchestra Pipe Organ.

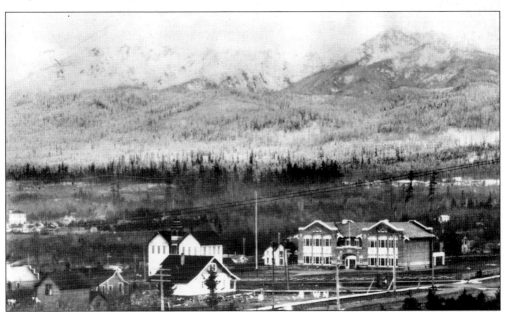

The Lincoln School block was set aside for a school by David O'Brien in 1890. An earlier white school is to the left. The first stage of the brick building was completed in 1916. The school is the future home of the Museum of the Clallam County Historical Society.

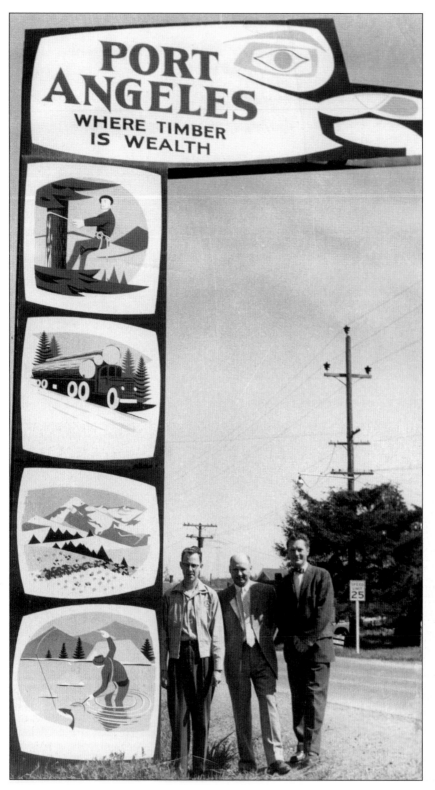

This sign was erected by the Active Club in the late 1950s after Port Angeles was recognized as an All-American City. From left to right are an unidentified man, Eldon Anderson, and Vince Keller.

Five

THE WEST END

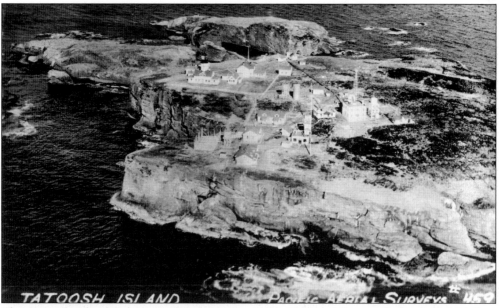

The Tatoosh Island light was placed on this rocky island at the northwest tip of Clallam County in 1857. This photograph was taken as part of the Pacific Aerial Survey about 1950. It shows the second light house, the signal station and other support buildings. The light house is no longer manned although it is still operating.

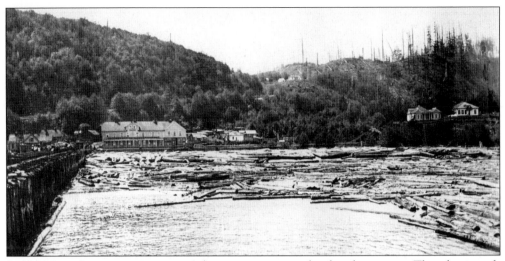

In 1889 Port Crescent was envisioned as a major port and railroad terminus. This photograph taken in 1903 shows the Markham Hotel, pioneer store, newspaper office, and a few other town structures.

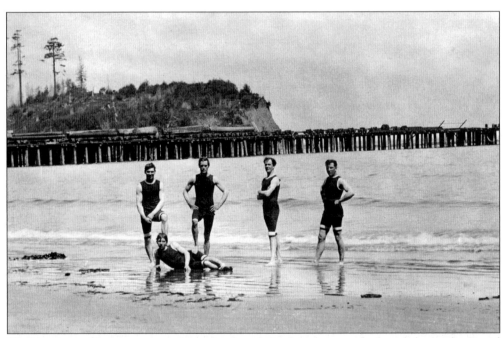

Working in a mill town was not always hard work. In this photograph, from left to right, David Burrowes, Mickey Griffen, Wm. Dennis, Joe Joyce, and Garf Davis show off the latest in men's swimwear with a dip in beautiful, cold Crescent Bay.

In the beginning the towns at the east and west sides of Clallam Bay were both named Clallam. Later the town on the west was named Sekiu. The name Cottage Row was given to these matching dwellings in Sekiu during the prosperous logging and fishing period.

The Sekiu school was built in 1916. Students posed for this photograph before the white landmark building about 1930. The building was named to the National Register in 1991. Today it serves as the Sekiu Community Club.

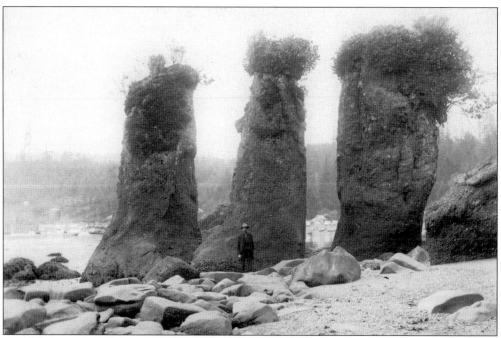

Three Sisters is the name given to these unique formations. They were originally formed by tidal action in the harbor and surrounded by salt water when the tide was in. The land around them has since been filled in to create a parking and picnic area.

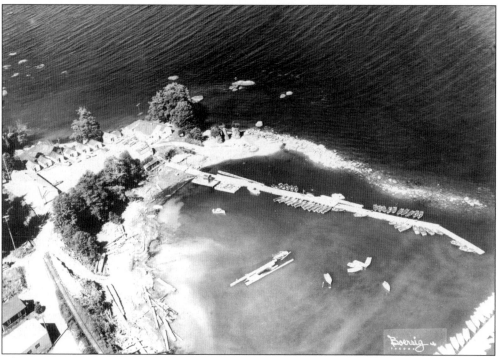

Olsen's Resort was a popular fishing resort at Sekiu during the 1960s and '70s. The sweep of the local landscape is shown in this aerial view.

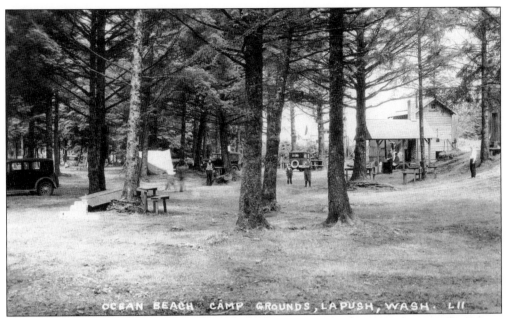

Ocean Beach Campgrounds at LaPush offered striking views of the beach during the 1920s. They have been succeeded by modern motel units.

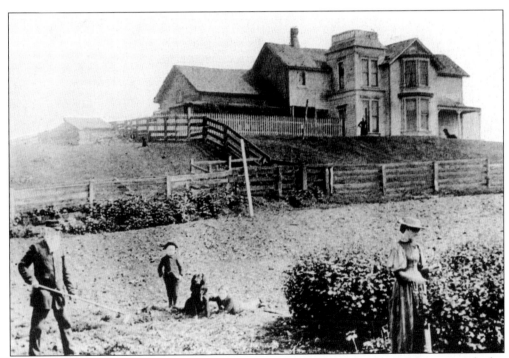

Daniel Pullen came to LaPush in 1878, set up a store, and built this beautiful mansion for his family. When he went to seek his fortune during the Yukon gold rush the Indians took all of the merchandise from his store. He later moved to Forks.

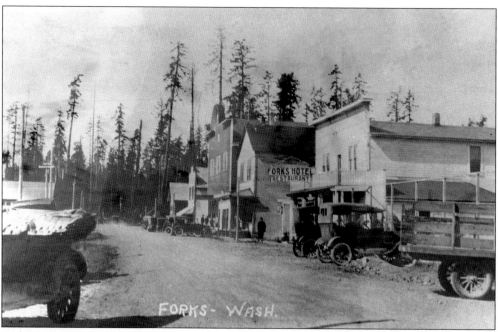

Forks was typical of many of the small communities that served nearby logging camps and farmers during its early days.

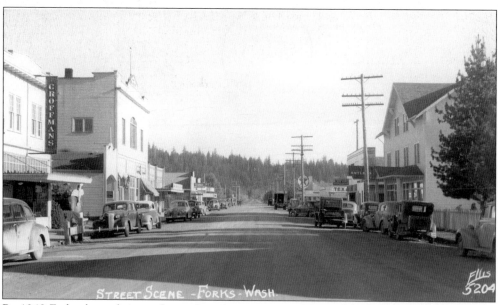

By 1948 Forks showed signs of growth and permanency. Most of the buildings on one side of the street had been destroyed in a fire in 1926. Only the fire equipment from the Forestry Service camp at Tyee saved the remainder of the town. Forks has since been rebuilt.

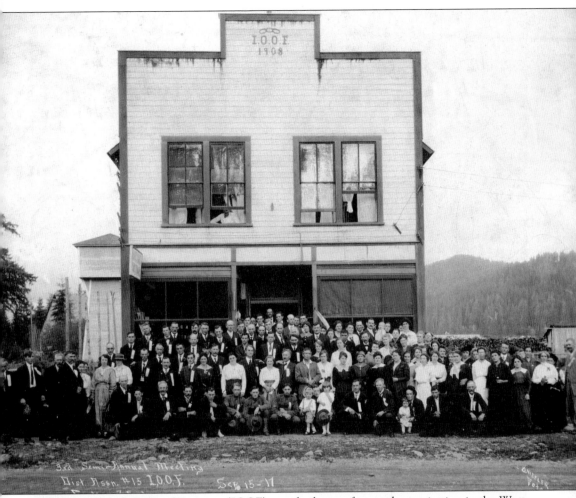

The International Order of Foresters (IOOF) was the largest fraternal organization in the West End. This large lodge building with commercial space on the ground floor was the tallest building in the town of Forks.

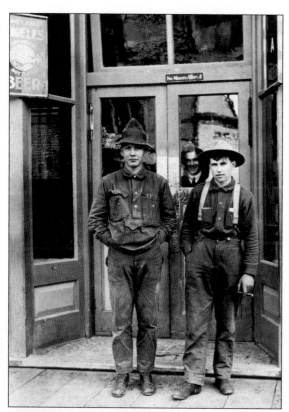

Two young loggers, William Nelson and John Schultz, stood outside a Forks tavern while Larry Harris looked out the window at the photographer.

Shopping was not an every day occurrence and shoppers in rural communities made few trips to town. This man has really loaded his car inside and out with groceries and merchandise to last for the next few months.

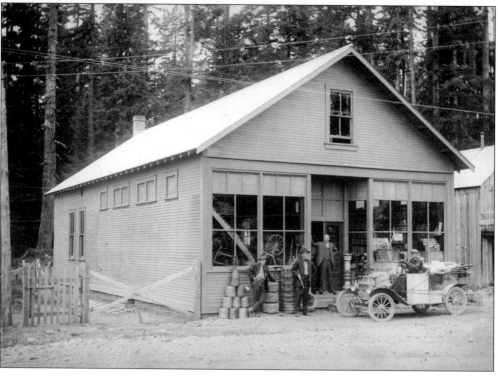

Early in the morning of September 20, 1951, a fire began at a logging site in the Sol Duc area. It traveled 17 miles in 8 hours, threatening the town. It swept over 35,000 acres of forest land, destroyed houses, out-buildings, and logging equipment, but spared most of the town of Forks.

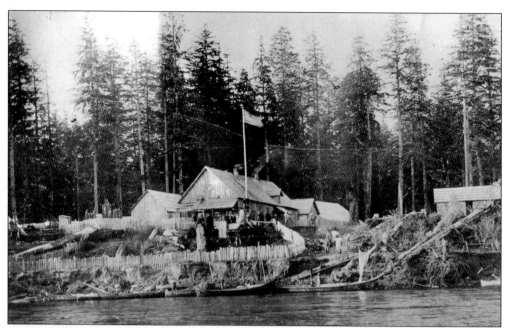

The community of Boston was begun on the Quillayute River outside the LaPush reservation. Frank T. Balch established a store and post office there at the fork of the Dickey and Quillayute rivers.

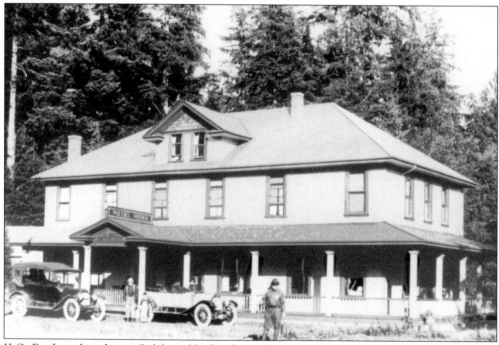

K.O. Erickson bought out Balch and built a larger hotel and store. When he was told he had to change the name of the post office from Boston he named it Mora, for Mora Parish in Dalarna, his Swedish home.

In the Royal area, near Lake
Ozette, Ole and Brit Boe posed
with the children Emmert and
Anna in 1899 near their
homestead.

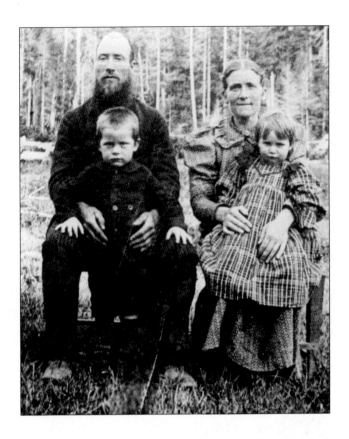

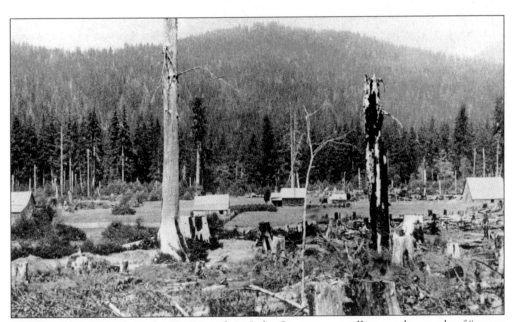

This Royal homestead, up the Big River from Lake Ozette, was really a good example of "stump
farming."

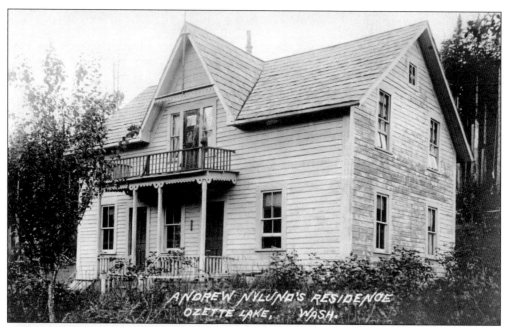

Anders and Johanna Nylund built this two-story home near Lake Ozette for their large family after arriving there in 1892.

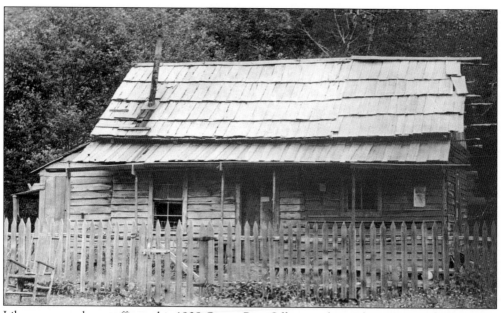

Like many rural post offices, this 1908 Ozette Post Office was located in a private home.

The Slip Point Light House, at the east side of Clallam Bay, was built and lighted in 1905. The keepers' house was a quarter of a mile away around the point. The lighthouse is no longer in existence; the light is located on a platform in the Strait of Juan de Fuca.

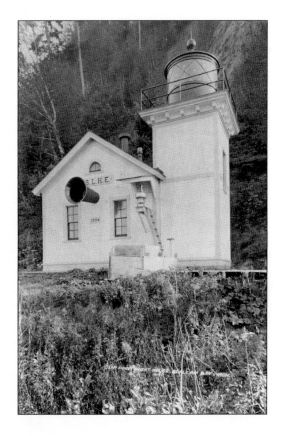

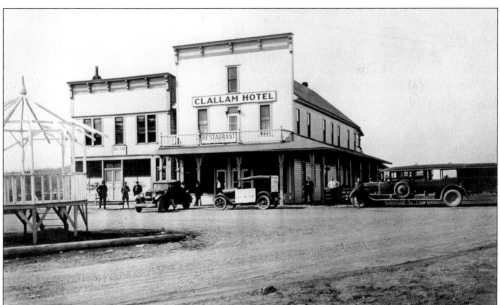

By 1919 Clallam was a thriving port town. It was the end of the line for the Wolverton Bus Company, and had several hotels and other commercial businesses. A few years before this picture was taken, the Doctor Building had been the hospital.

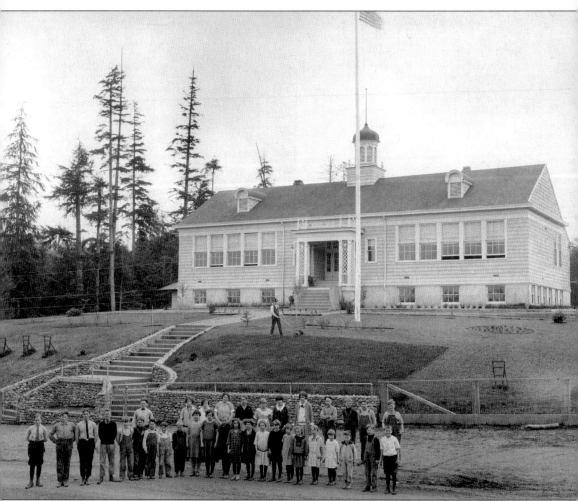

In 1924–25 students lined up for their photograph in front of the Clallam Bay School. From left to right, the students are: (front row) Albert Boe, Bob Cramer, Browning Bailey, Walt Rayment, Floyd Maneval, LeRoy Willet, Roland Murray, Raleigh Olesen, Virginia Maneval, Lucille Rayment, Blanche Cramer, Helen Rayment, Thelma Galivan, Lillian Tuttle, Marian Rasmussen, Geraldine Mooney, Alice Raymond, Alice Weel, Esther Weel, Roy McKee, Edward Maneval, and LaVerne Bailey; (back row) Vail Rasmussen, Vivian Sands, Esther Hanson, Grace Chesnes, Ada Nelson, Myrtle Oleson, Gertrude Lein, Miss Johnstone, Alston Raymond, Bud Rasmussen, Thomas Willet, and Harry Galivan. The janitor mowing the lawn was Mr. Wynn.

Gettysburg, on the Strait of Juan de Fuca east of the Lyre River, was typical of the logging towns built with great plans for the future. Robert Getty founded and built Gettysburg. The hotel pictured here was built and run by the Minnihan family.

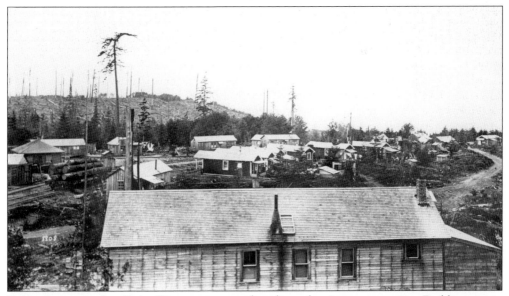

Twin, between the Twin Rivers, was another large logging community. Buildings were constructed so they could be moved by rail to the next logging camp. The hill behind had already been logged.

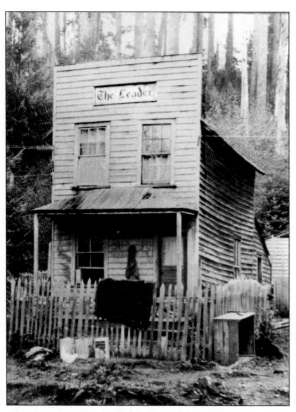

Sappho was homesteaded by Frank Ackerly, who later platted a townsite and sold lots. It was halfway between Clallam Bay and Mora and a logical overnight stopping place for travellers. Later the town was moved two miles south to the junction of Highways 113 and US 101.

Port Crescent disappeared after the rail line failed to come to Crescent Bay. The new community of Joyce was built five miles south beside the railroad tracks. Joyce Railroad Station is used as a museum today. Named for Joe Joyce, the new town was built using many of the Port Crescent buildings.

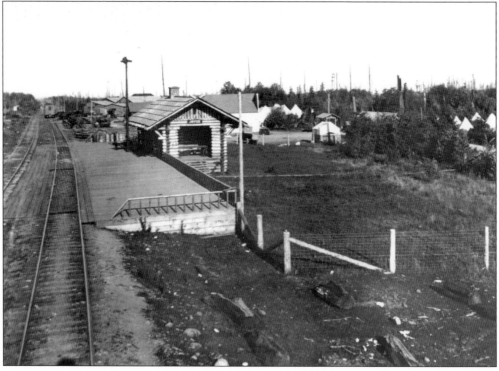

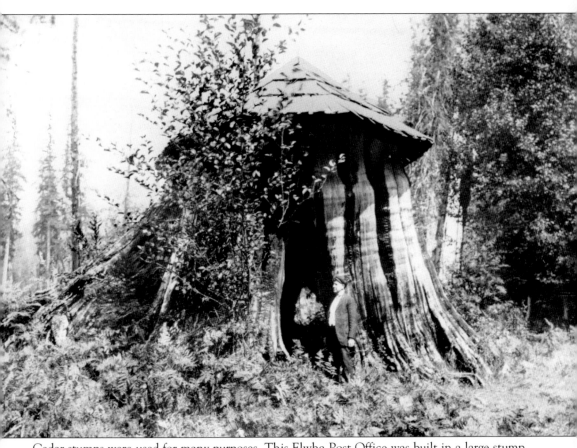

Cedar stumps were used for many purposes. This Elwha Post Office was built in a large stump. The conical cedar roof replaced the original roof. Stumps were occasionally used as homes by the first settlers.

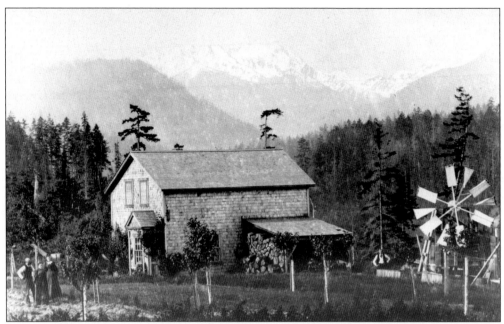

After the first wave of settlers in log cabins, homes were built of "sawn" lumber. The Peters' home above Dry Creek was a fine example. Laura Hall Peters and her husband were originally members of the PSCC. She was a leading suffragette at the turn of the last century.

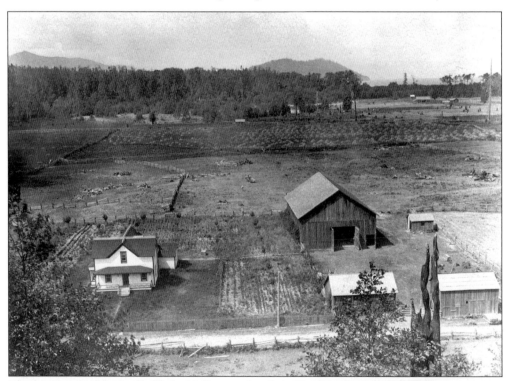

This prosperous farm in the Elwha Valley was developed by Pete Rasmussen. Today it is on part of the Lower Elwha Klallam Reservation.

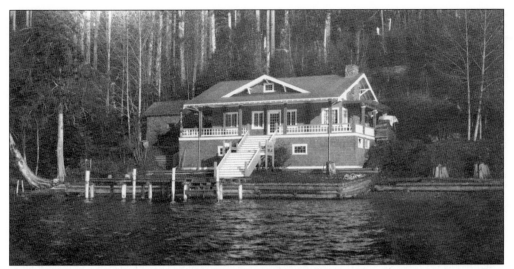

Private homes were built along the shores of Lake Crescent. This "cabin" built by Chris Morgenroth on Barnes Cove is an example of a place built as a weekend retreat. Notice the firewood stacked beneath the three story home. (Courtesy of Mary Morgenroth.)

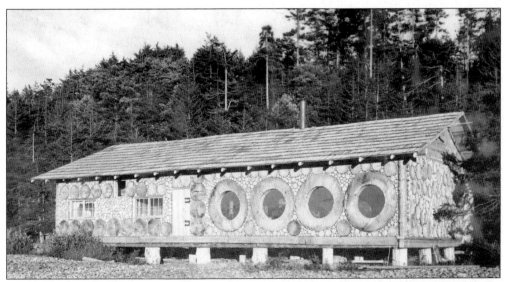

Another unique home was this built at "The Place" near the mouth of the Elwha River in the 1920s by Adelbert Smith. The unique construction used sawed round log pieces. Later "The Place" was used as a camp and resort.

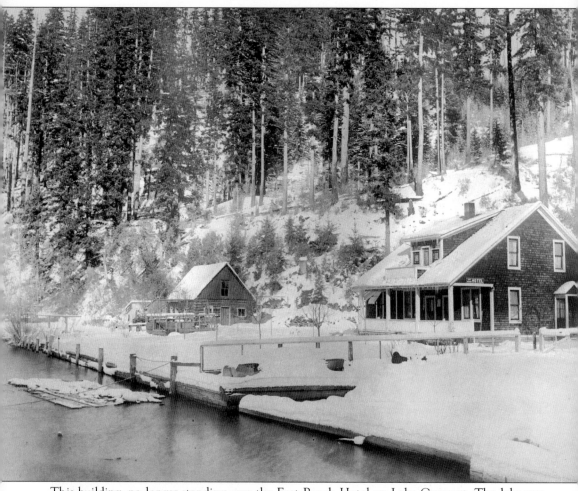

This building, no longer standing, was the East Beach Hotel on Lake Crescent. The lake was beautiful and quiet during the winter months.

Six
TRANSPORTATION

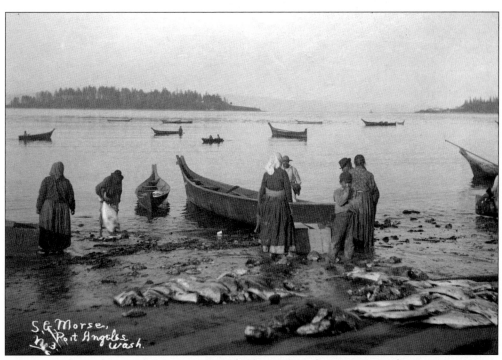

Canoes, similar to these Makah canoes, were the first means of transportation from one community to another along the Strait of Juan de Fuca and the Pacific Ocean coast of Clallam County.

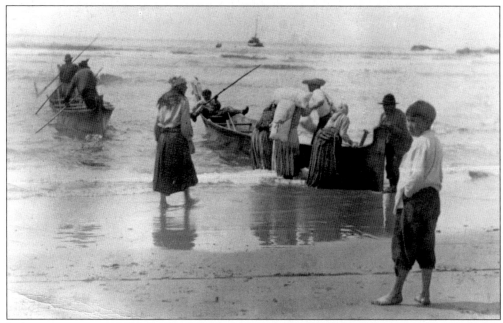

Indian canoes were used in many coastal towns to unload merchandise and passengers before docks were built. These Quileute Indians were unloading K.O. Erickson's schooner to take store goods up river to his trading post at Mora.

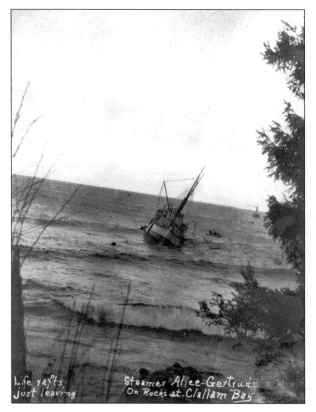

Life rafts just leaving

Steamer Alice-Gertrude On Rocks at Clallam Bay

The steamer *Alice Gertrude*, one of the regulars on the mosquito fleet run from Seattle to Neah Bay, ended on the rocks at Clallam Bay. The life rafts were just leaving the ship when the photograph was taken. She was later refloated, repaired, and sailed again.

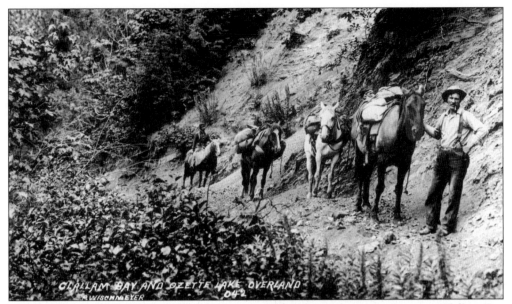

Land transportation began with pack trains on crude trails similar to this between Clallam Bay and Lake Ozette. Henry Belden on horseback in the rear and Ole Klaboe (leading the front horse) were photographed in 1909.

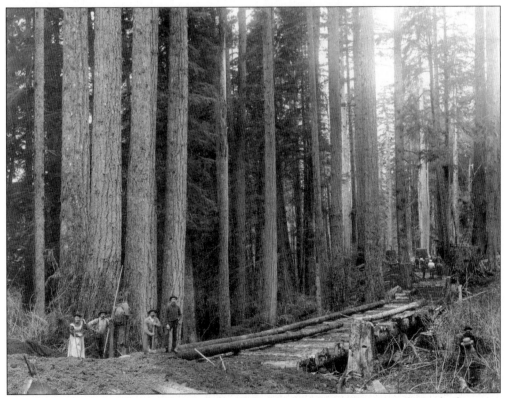

Many of the early roads were first logging roads. This road near Twin was being built over a creek. Mrs. Rose Dillon and Joe Dillon are pictured at the right. Others are unidentified.

The many rivers and deep ravines on the Olympic Peninsula required bridges. This covered bridge over the Elwha River took auto travelers to the trail up the river.

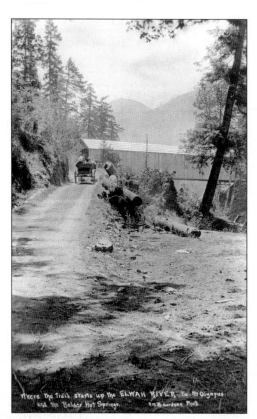

Where the Trail starts up the ELWAH RIVER To Mt Olympus and the Boldes Hot Springs. Em Richardson Phot

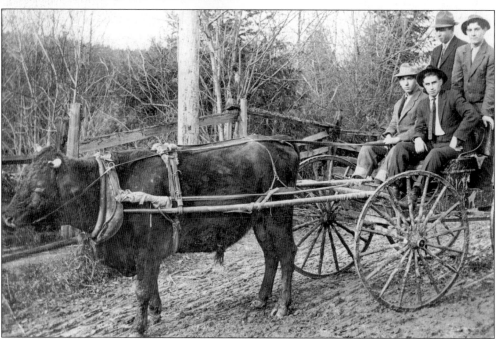

Horses and oxen were used for pulling power before automobiles took over. Four unidentified men are pictured on a two-person buggy being pulled by oxen. (Bert Kellogg Collection.)

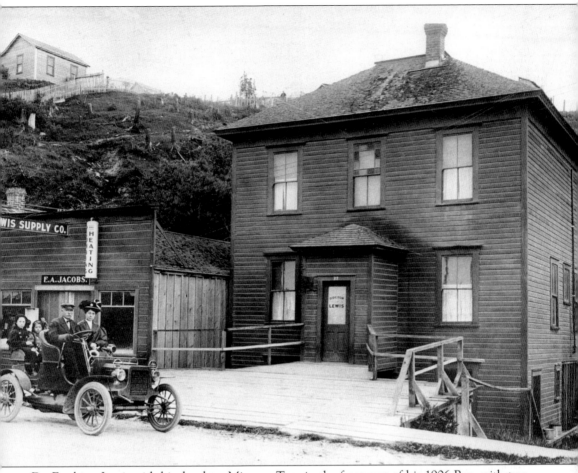

Dr. Freeborn Lewis with his daughter Minerva Troy in the front seat of his 1906 Reo, with two granddaughters in the rear, was photographed in front of his office on First Street in Port Angeles in 1914. His office/home is now the site of the Federal Building at First and Oak Streets.

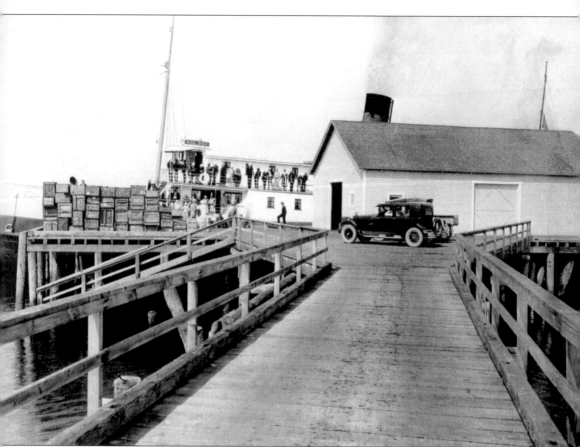

The *Sol Duc*, a ship of the mosquito fleet, unloaded passengers and cargo while a car waited on the dock. This photograph may have been taken at Port Williams.

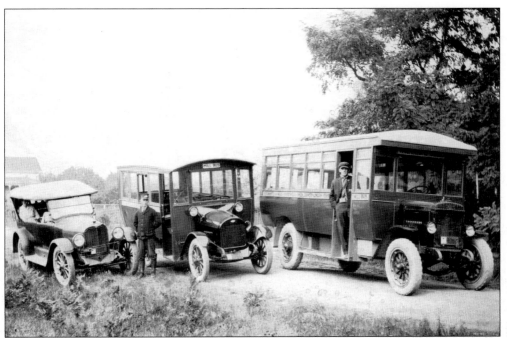

D.A. Wolverton (far right) drove busses and owned the Wolverton Bus Company. He posed with three of his vehicles: (from left to right) a taxi, a Mill bus, and the stage which ran on regular routes from the mills to Lincoln Heights. Wolverton built the bodies to suit on the chassis.

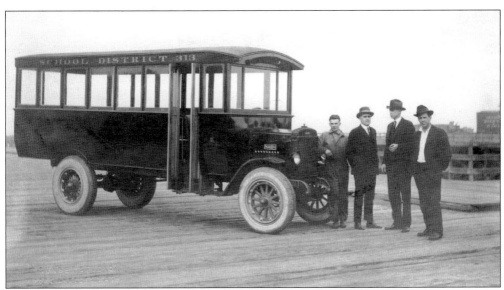

Eventually even school districts went to motorized transportation. Posing with a new bus for School District 313 are, from left to right, Biz Gehrke, an unidentified man, Wes Goodwin, and Frank A. MacDonald.

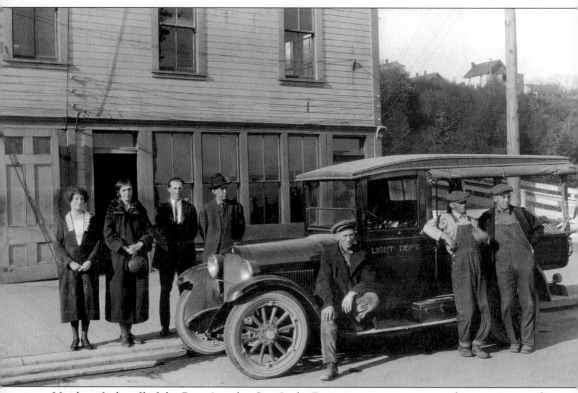

Unidentified staff of the Port Angeles City Light Department came out to admire a new truck in 1926.

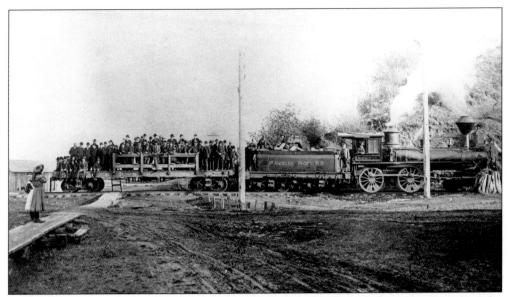

Port Angeles Mayor Norman Smith was so eager to have a railroad in his city of Port Angeles that he bought a locomotive that he named "Norman" and built one mile of track up Tumwater Valley to create the Port Angeles Pacific Railroad.

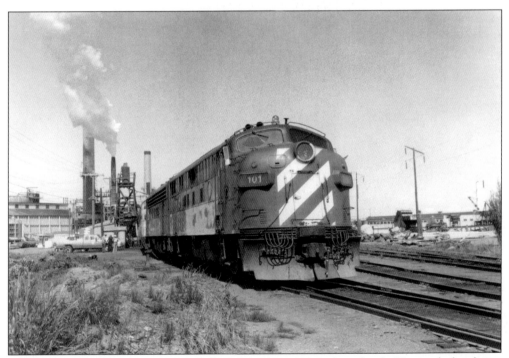

When the railroad finally came to Clallam County in 1914 it lasted only 70 years before being replaced by large trucking firms and good highways. This last train of what was the Milwaukee line is pictured leaving the Crown Zellerback mill in 1985.

The first plane in Port Angeles landed on the street at First and Cherry in June, 1915. A Canadian flyer landed and took off on the plank street, much to the amazement of onlookers.

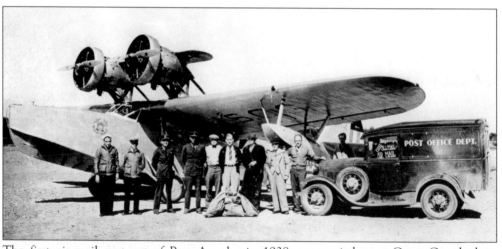

The first air mail sent out of Port Angeles in 1938 was carried on a Coast Guard plane commanded by Lt. Commander Norman M. Nelson and piloted by Lt. W.H. Snyder. It carried 2,362 special air mail letters written by Port Angeles school children and other citizens. Andrew J. Cosser was the Port Angeles Postmaster who arranged the event.

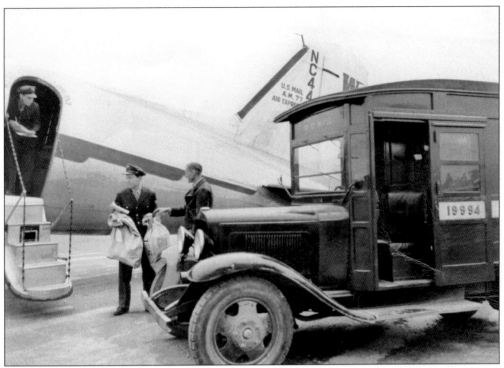

West Coast Airlines carried the first regular air service into Port Angeles in the 1930s.

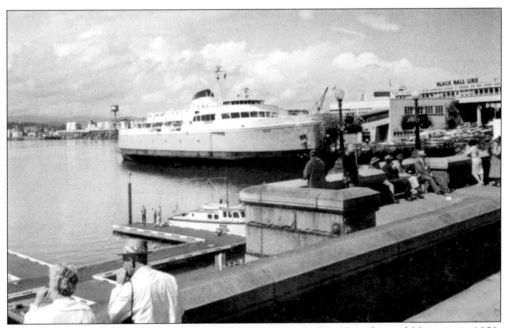

The Black Ball Ferry Coho began its regular run between Port Angeles and Victoria in 1959. This is a postcard view of the Coho arriving in Victoria.

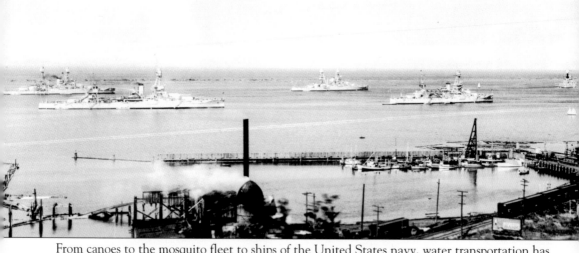

From canoes to the mosquito fleet to ships of the United States navy, water transportation has always been important in Clallam County. The beginnings of the Port Angeles boat haven are seen in the foreground.

Seven

OCCUPATIONS

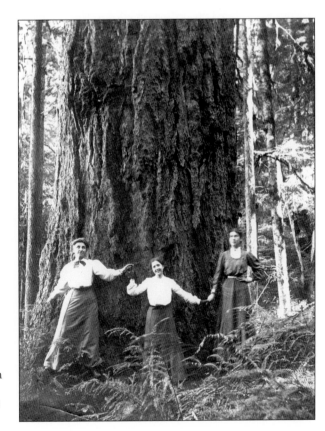

Forestry and forest products were the mainstay of Clallam County economy for many years. This photograph of three young women circling a Douglas Fir shows the typical size of old growth trees the early settlers found here.

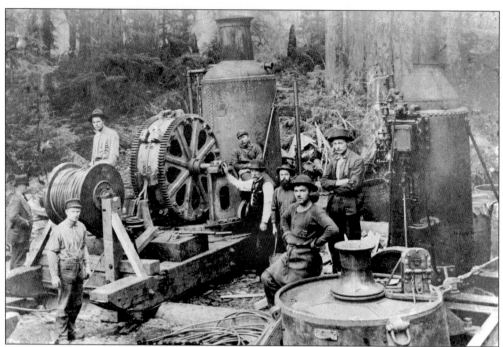

Unidentified loggers pose with two different types of donkey engines at a logging site. The engines were placed on sleds and pulled to the yarding areas as needed.

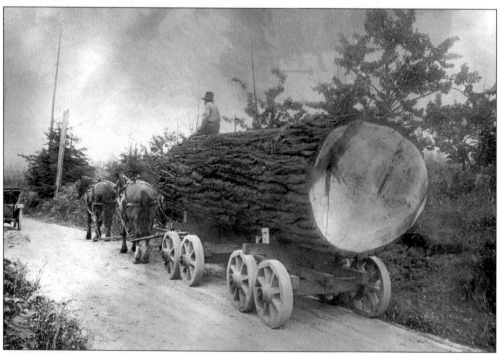

Moving old growth logs to the mill was a big job. Here a two-horse team pulled a Douglas fir log which completely filled an early truck. The unique wheels were probably of local manufacture.

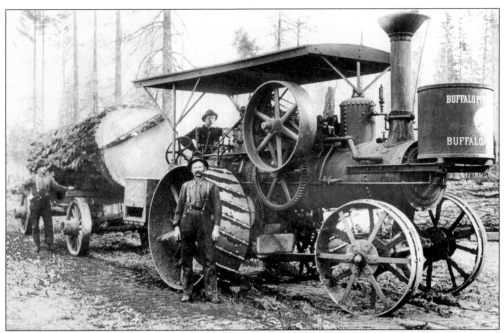

An early Buffalo tractor was used to transport logs. (Bert Kellogg photograph.)

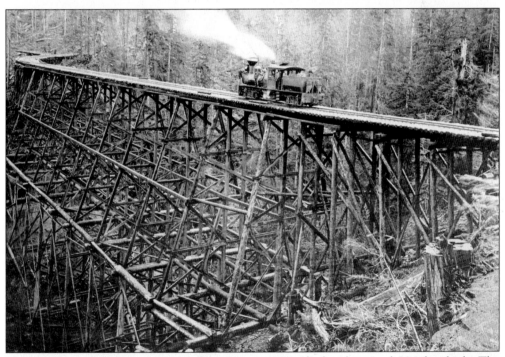

This trestle over a ravine near Clallam Bay was 804 1/2 feet long and 204 feet high. The builders started from the bottom using a special bridge-upon-bridge construction technique. It was said that most of the train crew would walk across the trestle first; the engineer would get up steam and step out of the locomotive, letting it pull the train across with no crew. On the other side, the crew would "catch" the locomotive and stop it until the engineer arrived.

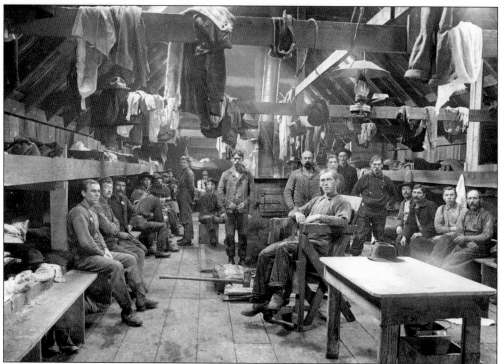

This picture of the interior of a logging camp bunk house was taken somewhere in the Clallam Bay area prior to World War I. It has been said that the photograph lacks "only the sight of bedbugs and the stench" to be completely authentic.

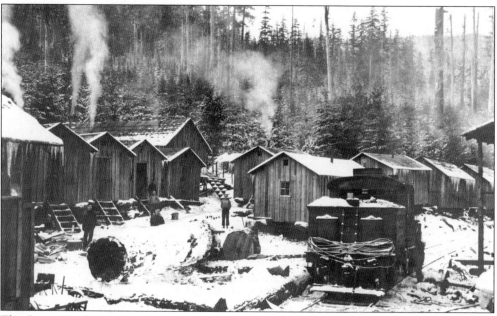

The Snow Creek Logging Company outfit was typical of the companies that moved into the Blyn area at the turn of the 20th century. The bunk houses were small enough to be moved from one camp site to another by train as the timber ran out.

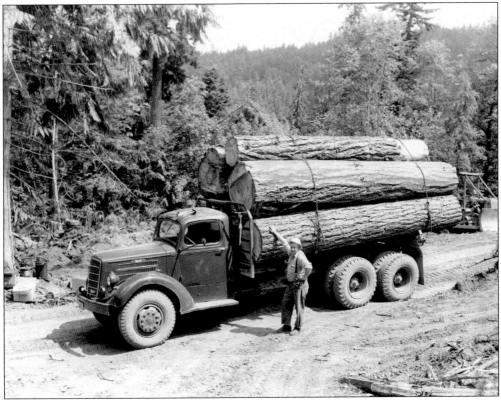

Logging equipment became more modernized before World War II. Sandy Keys Sr. was transporting logs out of a yarding area to a mill. Over the years trucks have become larger and the logs smaller.

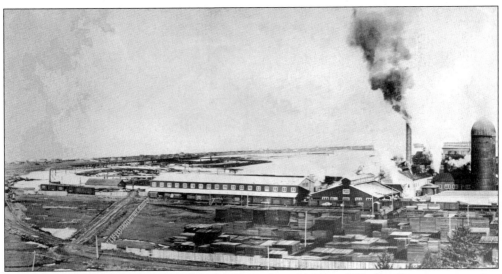

When Michael Earles built this mill for his Puget Sound Mill and Timber Company operation it was the largest mill in the state.

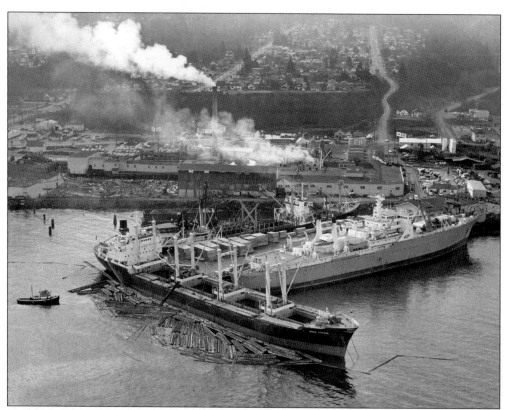

Lumber and logs from the forests of Clallam County were loaded on ships in the Port Angeles harbor for shipment around the world. Such shipping activity is the exception, rather than the rule, today.

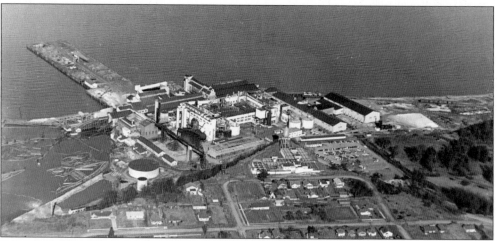

Rayonier Mill is shown at the Ennis Creek site where the Puget Sound Cooperative Colony built the first lumber mill in the county. It has been dismantled and the site is being cleaned up for other uses.

Dashiowa Mill at the base of Ediz Hook is the last of the large mills remaining in the county. It was originally Washington Pulp and Paper, then James Brothers, and Crown Zellerback before being taken over by Dashiowa.

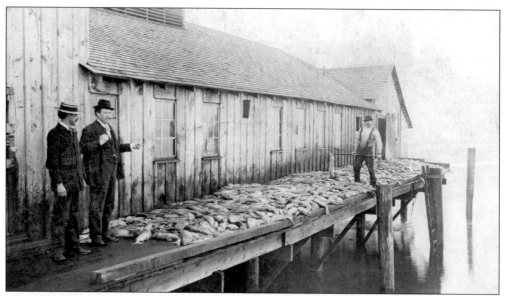

This photograph shows salmon which have been loaded on the dock outside an early salmon cannery in Port Angeles in the late 1800s. The identities of the men are unknown.

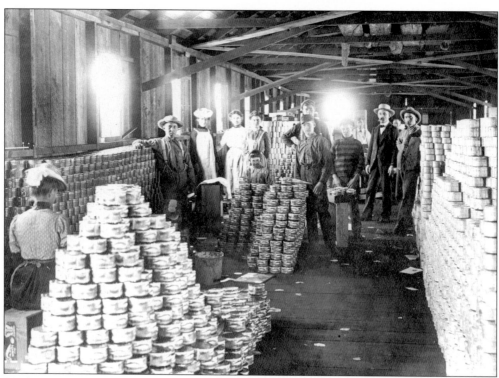

Workers and visitors posed with cans of salmon that had been processed in this early Port Angeles fish cannery.

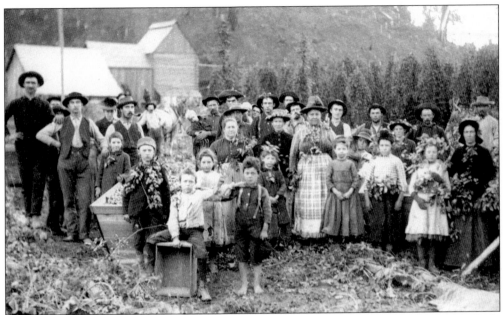

Although almost every early settler had his own kitchen garden; agriculture was fairly specialized. In the Forks area hops were grown and harvested for a number of years.

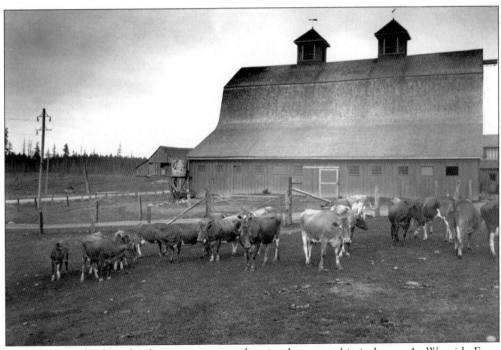

In the East End, where land was more open, dairying became a big industry. At Wayside Farm Willis Chambers raised a fine herd of Guernseys and Jerseys. At one time there were more than 500 dairies in the county; today there are fewer than 10.

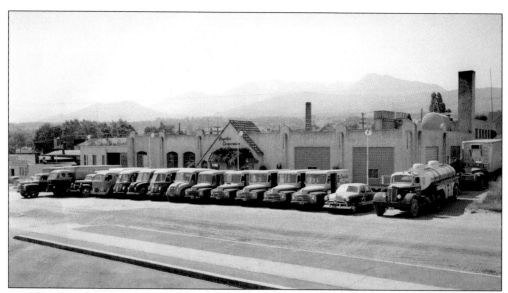

Angeles Creamery in Port Angeles gradually assimilated all small dairy operations, and farmers found it more profitable to sell their milk to the creamery than to process it themselves. As transportation and refrigeration methods improved, larger East Puget Sound dairies bought most of the peninsula milk.

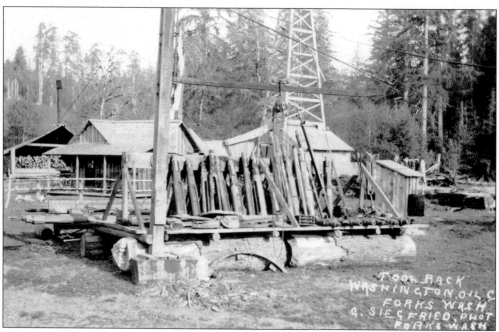

For a while during the first half of the 20th century a gas and oil boom rocked Clallam County. This exploratory well operated near Forks. Petroleum was not found in enough commercially viable quantities to continue the operations.

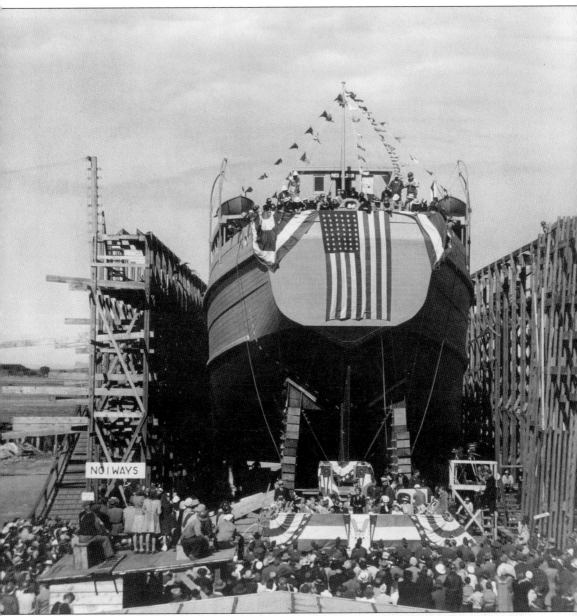

During World War II the Olympic Ship Builders launched *Red Alder #1*. At that time, Mrs. Eleanor Roosevelt came to Port Angeles with her daughter, who dedicated the launch. The ship was built of wood to haul coal to England during the war because wood hulls would not attract torpedoes.

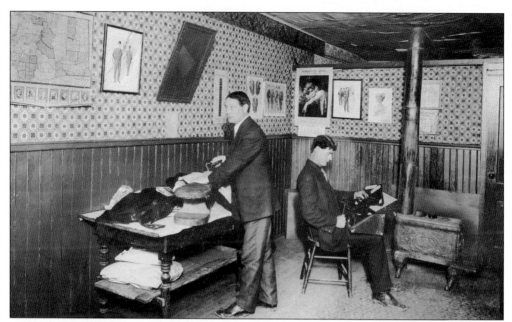

Personal manufacturing on a small size was exemplified by this local tailor ship which did a thriving business in the early years of the last century.

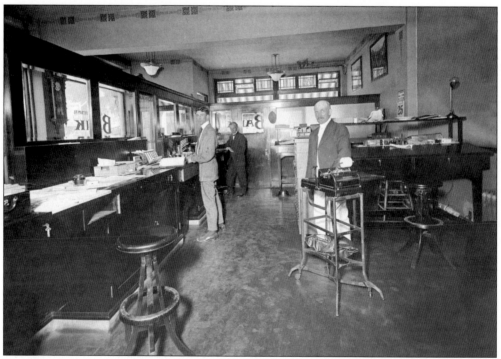

J.P. Christensen was first cashier, then the manager of the Citizens National Bank. This photograph was taken between 1903–1905.

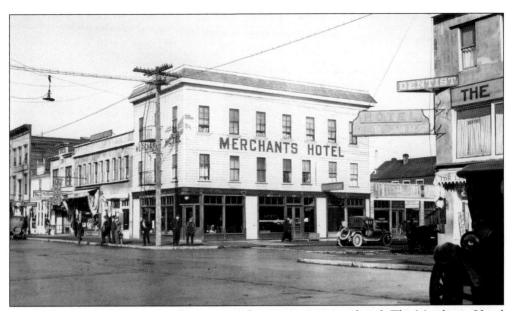

One of the first buildings erected in every early community was a hotel. The Merchants Hotel on the northwest corner of Front and Laurel Streets was popular with travelers. It was only one block from the ferry dock and close to the railroad depot.

The Morse Building on the corner of First and Oak Street housed professional offices on the second floor; retail businesses were located on the ground level.

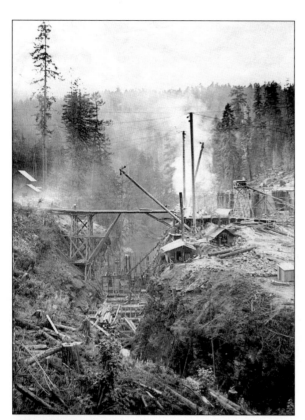

Thomas Aldwell's dream was to have enough electric power to bring big industries to the North Olympic Peninsula. This view shows the canyon where the first Olympic Power Company dam was built on the Elwha River in 1914.

The first Aldwell dam blew out before it went into operation because of faulty engineering. The dam was rebuilt at that site and later a second, Glines Canyon Dam, was built upriver. It was necessary to bring power to the mills and for domestic use. At one time the Elwha dams provided power for cities as far away as Bremerton.

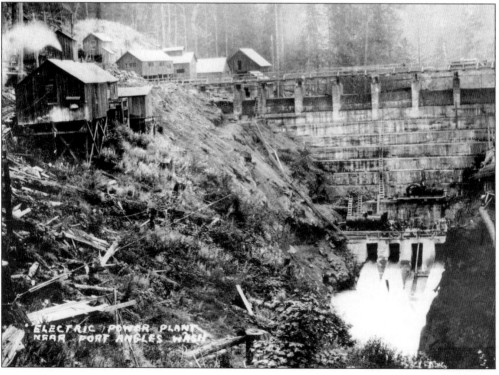

ELECTRIC POWER PLANT
NEAR PORT ANGLES WASH

Eight

RECREATION

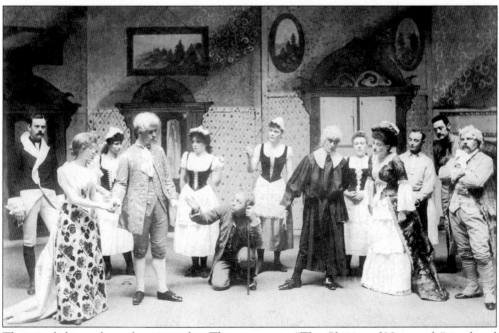

Theatricals have always been popular. These actors in "The Chimes of Normandy" produced the play in the Opera House in 1892 to raise money to have a painting of Port Angeles produced and sent to the World's Columbia Exhibition in Chicago in 1893.

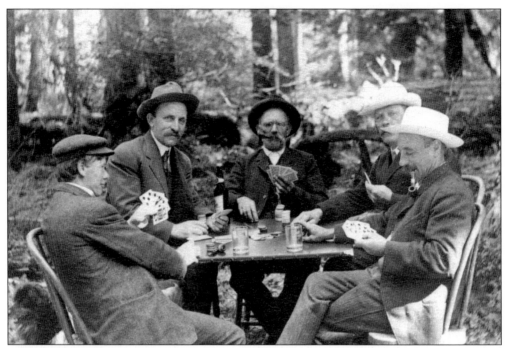

This photograph of the Scandinavian Poker Club taken in August 1909 is titled "The Black Hand."

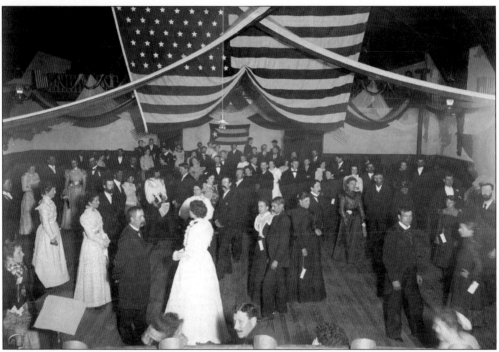

Residents of the county have always been ready to go to a dance. Whether it was a formal dance in the Port Angeles Opera House in 1890 or a barn raising dance in a rural area, they put on their dancing shoes and were ready to dance.

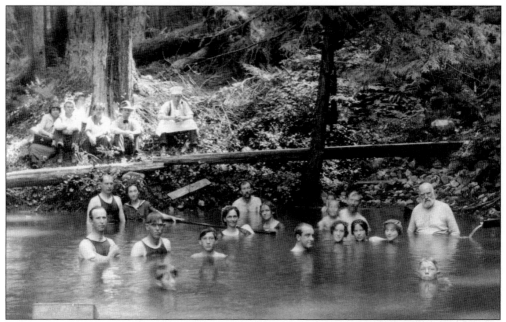

The Strait of Juan de Fuca is too cold for any but the most die-hard swimmers, so it was with pleasure that early residents and visitors hiked 12 miles from the nearest road to the Olympic Hot Springs. The gentleman bathing in his long-johns is James A. Smith of Port Townsend. The springs were later improved. Today they have been returned to their natural state and are included in the Olympic National Park.

Another popular outdoor activity has been hunting. These successful nimrods posing with six deer after a hunting trip include, from left to right, Charlie White, Dewey Shell, Harold Sisson, Ernie McKnight, Al McKnight, and (?) Travis.

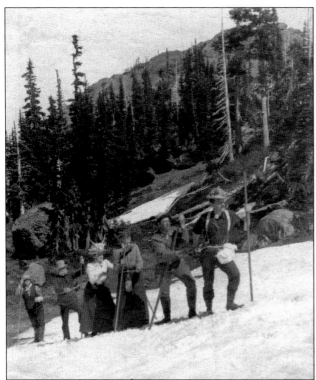

The Klahhane (an Indian word meaning "good times out-of-doors") Hiking Club was organized in 1915 and is still going strong. Here a group of hikers tested their skills on a snow patch during an early spring trip into the mountains.

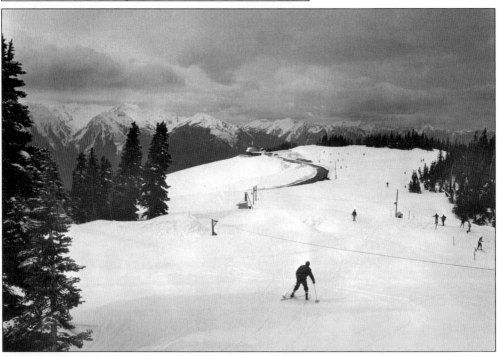

Doing a "fast forward" to the late 20th century, snow sports such as skiing and snowshoes became popular when the road to Hurricane Ridge was opened. Tourists like to be able to drive into the heart of the mountains.

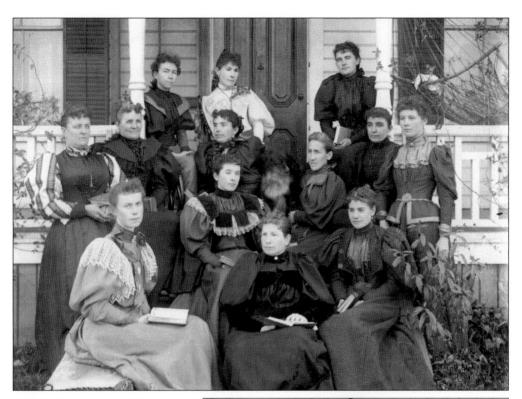

The Ladies' Society of Literary Explorers was one of several cultural organizations in Port Angeles in 1893. Members gathered outdoors for their group photograph. The dog in the center of the group could not sit still.

During the long growing season, residents enjoyed beautifying their homes with flower gardens. Mr. and Mrs. J.P. Christensen and the family cat were admiring their garden and roses. Garden Clubs have been very active throughout the county.

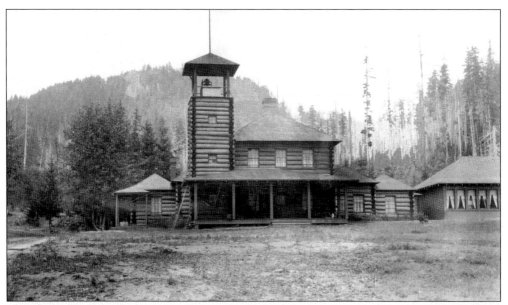

It did not take long for entrepreneurs to build resorts around Lake Crescent. In 1895, Port Townsend Customs Collector Saunders built the first Log Cabin Resort on the north side of the lake. After this structure burned in 1932, another was built. It is still a popular destination.

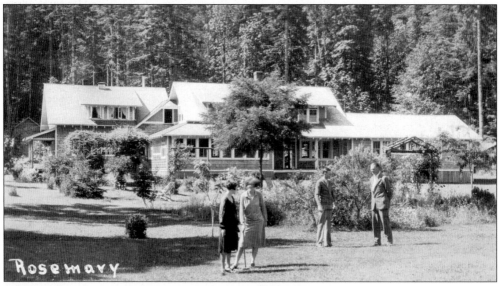

Rosemary Inn, built by Rose Saylor Littleton and Mary Daum in 1912, looks today much as it did almost one hundred years ago. Now within the National Park, it is the site of the Olympic Park Institute, retaining the same buildings and ambiance.

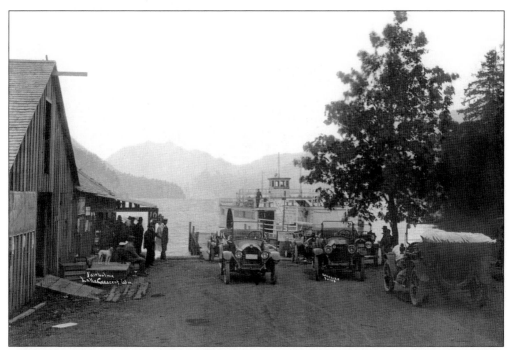

In the beginning resorts had their own boats to pick up vacationers at the end of the road. By 1914 Clallam County created the Lake Highway by building and operating ferry boats which took passengers and vehicles across the lake. Here the ferry *Marjory* unloaded cars at Fairholm on the west side of Lake Crescent so they could continue their trip on to Forks.

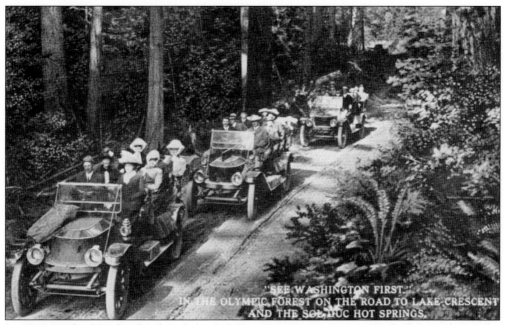

In 1912 Michael Earles developed the Sol Duc Hot Springs Resort. He built a road into the mountains and used a parade of Stanley Steamers to pick up guests at the ferry and drive them into the hills to the resort.

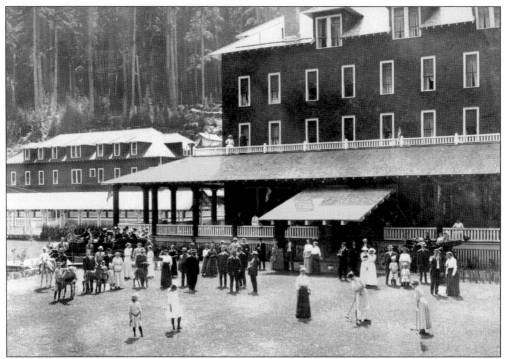

Earle's resort was a massive four-story hotel with 165 bedrooms and all the amenities of a European spa. Visitors stayed two or three weeks "taking the waters," bathing in the hot spring pools, and enjoying outdoor activities and healthy living.

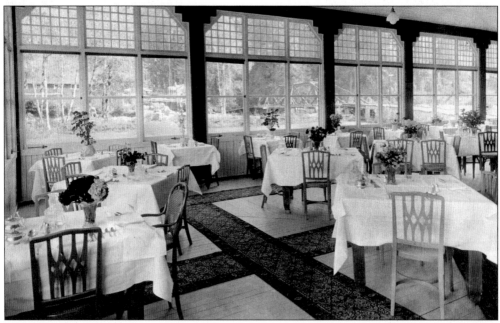

The resort dining room featured fine silver and china, gourmet food, and a magnificent view. The original resort burned to the ground in 1916 and a second, smaller hotel burned in the late 1920s. Sol Duc Hot Springs is part of the National Park now, but will never be as elegant.

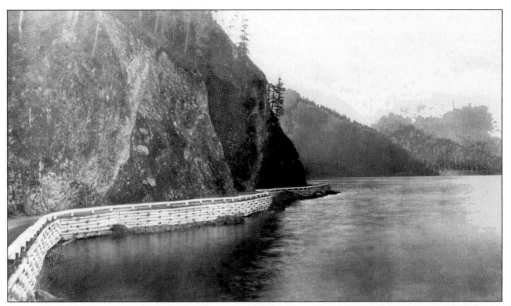

A road was carved out of the mountain on the south side of Lake Crescent in 1921–22. By 1927 guard rails were in place, the road was improved, and the Lake Highway was a thing of the past. Resorts turned their entrances to face the road, rather than the lake.

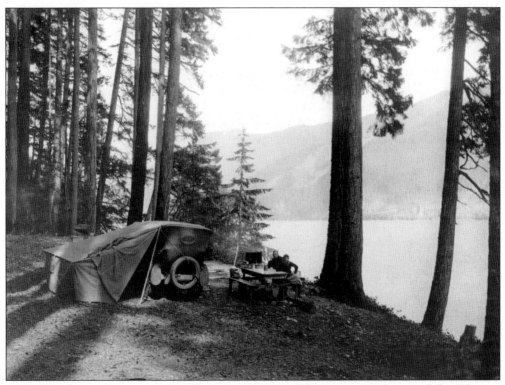

With the advent of better roads and improved automobiles, more people visited the Olympic Peninsula. Car campers stayed at LaPoel Camp on Lake Crescent. Today LaPoel is for day use only. (Courtesy Washington State Historical Society.)

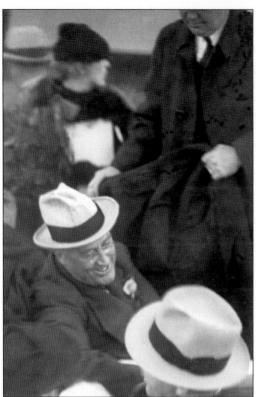

By 1937 agitation to have a National Park on the Olympic Peninsula was strong. President Franklin D. Roosevelt came to Port Angeles in late September and drove around the peninsula to see for himself. In 1938 the Olympic National Park was created.

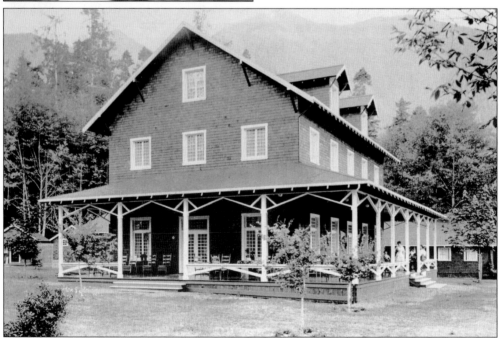

At Lake Crescent, Roosevelt and his party dined and stayed overnight at Al Singers Tavern, now Lake Crescent Lodge. The president spent the evening interviewing park enthusiasts. He stayed in a two-room cabin facing the lake. Today it is known as "Roosevelt's Cabin."

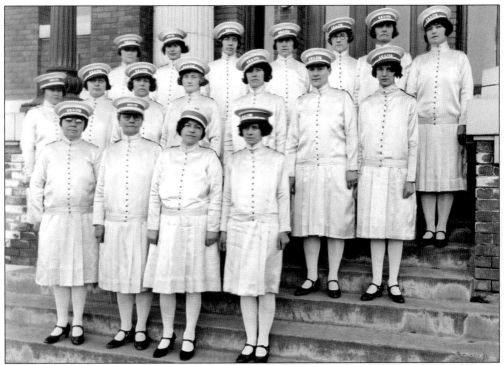

County residents have always been "joiners." The 1929 Drill Team of the Royal Neighbors of America lined up on the courthouse steps, from left to right, are: (front row) Ann Hickey, Captain Madge Bartholmew, Nora Gustafson, and Julia Lagalo; (middle row) Gladys Rudolph, Florence Gross, Rose Barr, Ida Wattham, Wanda Oakes, Rose Draper, and Mildred Lamb; (top row) Sarah Stone, Marion Eacrett Reed, Florence Hill, Mandy Payne, Frances Nunns (?), Ada Peterson, and Lettie Dorr.

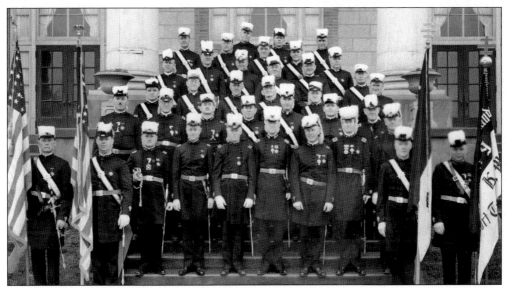

A unit of Knights Templars posed on the steps of the Masonic Temple in 1938. They marched in every parade.

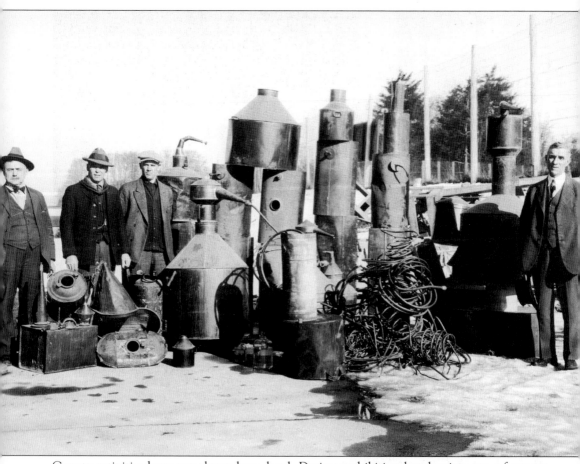

County activities have not always been legal. During prohibition bootlegging was a frequent happening. There was a lot of room in the wilderness to set up a still and produce homemade moonshine. Here Fred Rice, the sheriff in charge of liquor control in 1923, and his team posed with stills that were to be melted down for copper value and salvage. The proceeds were given to "Beacon Bill," Welch's Christmas Collection for the needy.

Winners of the 1934 Junior Salmon Derby, James Rudolph and Sally Price, posed proudly with their fish. Salmon derbies for adults and children were popular into the 1980s when the fish runs were depleted and fishing curtailed.

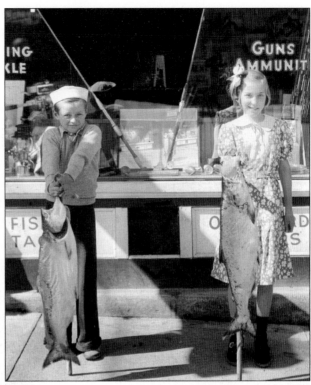

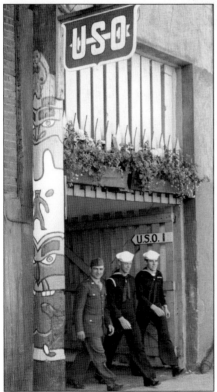

World War II brought servicemen from all branches of the armed forces to Clallam County to protect the peninsula from enemy attack. A USO was set up in the basement of the Elks Building.

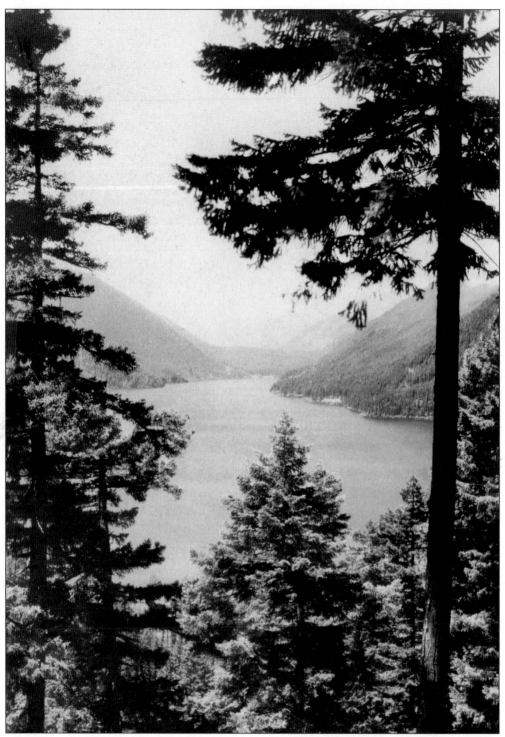

Lake Crescent was identified very early as the heart of recreation and the jewel of Clallam County. This early postcard view was photographed from a vantage spot on Storm King Mountain.